# HIDDEN HARMONY

# HIDDEN
# HARMONY

## The Connected Worlds
## of Physics and Art

## J. R. LEIBOWITZ

THE JOHNS HOPKINS UNIVERSITY PRESS

BALTIMORE

9 8 7 6 5 4 3 2 1

The Johns Hopkins University Press
2715 North Charles Street
Baltimore, Maryland 21218-4363
www.press.jhu.edu

Library of Congress Cataloging-in-Publication Data

Leibowitz, J. R. (Jack R.)
    Hidden harmony : the connected worlds of physics and art / J. R. Leibowitz.
       p. cm.
    Includes bibliographical references and index.
    ISBN-13: 978-0-8018-8866-3 (hardcover : alk. paper)
    ISBN-10: 0-8018-8866-2 (hardcover : alk. paper)
    1. Art—Philosophy.   2. Physics—Influence.   3. Science in art.   4. Art
and science.   I. Title.
    N70.L454   2008
    701'.05—dc22                                                    2007043958

A catalog record for this book is available from the British Library.

*Frontispiece:* Kinga Czerska, *Metamorphosis,* oil on canvas, 40 × 60 in. (detail). Reproduced with permission of the artist.

*Special discounts are available for bulk purchases of this book. For more information, please contact Special Sales at 410-516-6936 or specialsales@press.jhu.edu.*

The Johns Hopkins University Press uses environmentally friendly book materials, including recycled text paper that is composed of at least 30 percent post-consumer waste, whenever possible. All of our book papers are acid-free, and our jackets and covers are printed with recycled content.

*To Ariel,*

*to Jane and Jon, and*

*to Ali and Zach*

# CONTENTS

*Preface*   ix

1. The Mind's Eye as Interpreter   3

2. What Is Saved and Why   9

3. What Is Broken and How   21

4. The Balance of Shapes   37

5. Some Visual Elements in Art   48

6. Searching for Light   64

7. Einstein's Relativity and the Escape from Relativism   74

8. Form in Impressionism and Postimpressionism   89

9. Cubism and the Expanding Horizon   110

10. The Growing Circle of Understanding   119

*Notes*   133

*Index*   143

During a memorable summer many years ago, I participated in a five-week retreat at the Aspen Center for Physics, nestled in the idyllic Rocky Mountains. I had been brought up in New England and had never, until then, been west of the Mississippi, and that first visit to the Rockies was a life-changing experience. I discovered a strangely self-luminous world of brilliant landscape, violet skies, and velvet air.

I immediately felt compelled to capture some of those images in charcoal and pastel chalks. It became clear to me that even those first stumbling efforts had the effect of marshaling the eye to keener *seeing*. Many years later, Sir Kenneth Clark, the renowned art historian, pointed out to me that, at the outset, he had wanted to be a painter. Although that experiment failed, he attributed some of his success as an art historian to those early, eye-sharpening experiences at the easel.

For me, a consequence of my drawing was a new appreciation of the visual arts. When possible, I would study a painting's *content*—that is, its cultural, social, and historical context—which enhanced my artistic appreciation and understanding. But I came to realize that my relative neglect of *form*—the internal dialogue brushed into the canvas or carved in the sculpture—had deprived me of a fuller aesthetic experience of art.

And with that recognition of the crucial role of form in art came the discovery that, without any deliberate plan, my viewing of the works of master artists seemed curiously guided by expectations deriving from my immersion in physics. In both great works of art and physics, I found a most satisfying compositional unity and internal coherence. Intent on sharing these found parallels between seemingly disparate domains, art and physics, I initiated an interdisciplinary course for liberal arts undergraduates. Surprisingly, students pursuing such diverse majors as art, literature, philosophy, and the sciences were gratified to discover, as I had been, a lens for revealing common ground in the composition of great works of art and the construction of significant physical theories.

Over the intervening years, my understanding of the bridge between art and physics has further evolved and inspired the writing of this book. It is intended for a wider audience in the hope that what I have found to be a rewarding discourse between art and physics will please others as well. For this purpose, I have endeavored to present the enmeshed subjects of art and physics at a level that presumes no prior exposure to either. Particular examples from the visual arts and physics have been selected for their potential to illustrate such connections directly and transparently. Guided by that purpose, I have pointedly turned against presenting a broad survey or history of either art or physics.

The book is for those who wish to open fresh eyes for seeing, both in the visual arts and in our physical world. The only prerequisite is a willingness to consider the possibility that Michelangelo, Cézanne, and Picasso were exploring the same world as Maxwell, Einstein, and Schrödinger.

Mathematics is used in only one place in the book (chapter 7), and, even there, its use is not for calculation. Rather, it is presented for its symbolic value, in the same way that tourists find meaning when given a guided tour of Egyptian hieroglyphs carved into limestone walls. The interested reader will find further explanations of the math and physics, along with further references, in the notes. The guided tour of art is also planned with the uninitiated in mind. In our walk through selected waystations in art, it is not my purpose to exhaustively examine art history or competing theories of art criticism. The literature exploring those domains is deep and wide.

Rather, the focus in both art and physics is on exploring a deep connection between them. At their heart, both great art and powerful physical theories have, at least at some points of contact, analogous positions on what is entailed in making great composition. While the word *composition* needs to be put into context in each of those two domains, what can be said straightaway is that there resonate in art and physics ideas such as symmetry, the "breaking" of symmetry, rebalance, and unity. It is the purpose of this book to put flesh on these ideas by examining a small number of selected examples from both art and physics.

In carrying through that objective, I do not plan an intimate mix, paragraph by paragraph, for that would suggest that these two domains are virtually identical in kind. Rather, I am interested in their common features despite

their admitted distinctness. So parallels are examined by grouping art and physics, as it happens, in alternating pairs of chapters.

I thank the editor-in-chief, Trevor Lipscombe, and the staff of the Johns Hopkins University Press for their support and guidance. I owe special gratitude to Allan Leventhal for his unwavering encouragement and belief in the project. I want to acknowledge helpful comments on an early version of the manuscript from the late Philip Morrison and from Gerald Holton, Lawrence Fagg, John Winslow, Virgil Nemoianu, and Ellen Kleiner. I also thank Jo Babich, Lynn Lown, Ingrid Merkel, Nancy Zimmerman, Michael Kessler, Kim and Juan Kelly of the Nuart Gallery, Anita West, and Albert Handell.

Special thanks go to the precocious grandchildren, Ali and Zach, the intrepid space travelers who piloted the relativistic rocket ships in chapter 7.

Finally, I am especially indebted to my wife, Ariel, who has been my constant support and my incisive sounding board. As it happens, she also was a key member of the flight software teams at NASA for both the Hubble Space Telescope and WMAP (the Wilkinson Microwave Anisotropy Project), responsible for the exquisite pointing programs that made possible the capture of the NASA photos shown in this book.

# HIDDEN HARMONY

# The Mind's Eye as Interpreter

Standing on a ridge, our German Shepherds, Zeb and Kyla, survey the landscape below. They take in a lavish canvas by marshaling their exquisite senses of smell and hearing and their ability to see at considerable distance the slightest motions, even amid confused tangles of brush and trees. Carefully assembled paint strokes, selectively arranged in the mind's eye, help them make sense of a scene that captivates them. I am exhilarated by the panorama of mountains, valleys, and violet skies. Is it the same scene they are relishing? I am adapted to coping with a somewhat different world and have little insight into Zeb's and Kyla's experience of theirs. All that can be said with some assurance is that the views each of us joyfully witness on that ridge are particular abstractions from a vastly more complex reservoir.

Our world is quite beyond our capacity fully to know or even imagine. The limitation isn't simply that our sight covers only a small piece of the electromagnetic spectrum: we are blind to infrared waves, radio waves, and longer waves, as well as, in the other direction of wavelength change, to ultraviolet, x-rays, and even shorter waves. Neither is the restriction fully to be understood in terms of the limited capabilities of our other senses, those of hearing, smell, taste, and touch.

Survival value has dictated the development of our senses. And while instruments of our invention have extended their reach, our senses nevertheless have both shaped and restricted our view of whatever it is we conceive of as reality. To paraphrase J. B. S. Haldane, the world is not only stranger than we know but also stranger than we can possibly imagine.[1] The truth of the statement should be embraced with awe and wonder by all of us. It holds forth the promise that there are things to be learned. At the same time, it reminds us that reality remains unimaginably beyond our ken and that there will always be a

tantalizing and abiding mystery. In what more humanizing and exhilarating adventure could we be engaged than the attempt to reach upward?

Explorers typified by the painter Paul Cézanne and the physicist Albert Einstein address distinct portions of this task by selectively filtering and interpreting the experience of their inner and outer worlds. Artists must reach beyond appearances. Even so-called realist art is generally an abstraction from the world of direct sensory experience. Many artists have commented on this. Pablo Picasso said that art is a lie that tells a greater truth. The painter Georgia O'Keeffe observed: "Nothing is less real than realism. Details are confusing. It is only by selection, by elimination, by emphasis that we get at the real meaning of things."[2] Toward this end Claude Monet might choose to paint blue shrubs and green skies and Vincent Van Gogh to render a starry night as a dazzling kaleidoscope of twisted, illuminated shapes. The modernist period in the visual arts, which began, arguably, with the work of Paul Cézanne, saw extension of that emphasis into the entirely nonrepresentational domain.

For the physicist as well, the world of everyday phenomena, explored by such pioneers as Isaac Newton, is quite different from that of the land of the quantum or the lands of particle physics and astrophysics, which have been increasingly revealed since the first quarter of the twentieth century. Here one enters unfamiliar ground, often guided only by mathematical description and strangely skewed metaphor adapted from the world of common experience.

The seemingly unconnected paths taken by the arts and sciences in the search for meaning intersect in surprising ways. Clues to the nature of those connections enter our consciousness when we open ourselves to the analogous compositional chemistries of great works of art and science. In exploring a few of these intersections, the visual arts—painting and sculpture—and the fundamental science—physics—shall be our touchstones.

## FORM IN ART AND PHYSICS

The arts make a distinction between *content* and *form,* terms representing, very broadly, the story being told and the means for expressing it. But, of course, these roles are interconnected: form influences the intended message, which, in turn, often suggests the most effective means for relating it. The subject of form and content in art is large and has been addressed from many directions.[3]

In the present work, *form* means the inherent language of art. More specifically, in art *form* shall refer to the principles and elements of design available to painters and sculptors. Of course, the terms *form* or *forms* also have a more conventional meaning, indicating shape(s), and it should be clear from the context which meaning is intended.

This book addresses art and physics from a commonality of form. It helps art viewers understand how to read what artists read in a painting, what the artwork within the frame has to say about itself. At the same time, it provides insight into basic underpinnings and aesthetic motivations of such pioneers as Einstein and his modern disciples.

Important connections between art and physics may be identified from the point of view of form. These connections illuminate and broaden our experience and understanding in both domains. The search for what may be termed coherent composition guides the artist and the physicist in their creative quest.

The viewer's experience of an artwork is enhanced when learning the story captured by the painter or sculptor. But it is further enriched when sharing in the artist's reasons for using particular elements of design in creating the artwork. Among a host of such elements, about which more will be said, are hue, arrangement of line, shape, and light and dark value.

Likewise, although many readers of popular scientific literature are entertained by new revelations in cosmology or quantum mechanics, their appreciation is furthered by awareness of the underlying considerations of form lighting the path to new discovery. This is clearly evident, as you will see, in the classical work of pioneers such as Maxwell and Einstein and in the path taken in much of modern physics.

The impressionists and postimpressionists increasingly emphasized form in art during the last quarter of the nineteenth century (see chapter 8). Such painters as Edouard Manet, Claude Monet, Pierre-Auguste Renoir, and Camille Pissarro introduced a new freedom of expression by relaxing sharp delineation of shapes and partially dissolving them in shimmering strokes of brush and hue. The artists moved away from grand themes and toward the depiction of ordinary lives and commonplace situations. Their modes of expression became freer.

Postimpressionist art began to speak even more emphatically about itself, its form. The shapes, tones, and hues in the semiabstract landscapes of Cézanne's late work helped usher in the modern era in art. During the six-year period

following Cézanne's death in 1906, Analytical Cubism, pioneered by Georges Braque and Pablo Picasso, moved even closer toward abstraction by breaking solid shapes and ultimately reassembling them from faceted shards.

Criteria based on form have also become centrally important as guides to discovery in physical theory. Symmetry and broken symmetry, ideas we shall develop in terms of concrete physical examples, point toward new and powerful physical insights. Here, as in art, the objective is discovery of coherent *composition,* guided in part by basic conservation laws, which identify quantities that remain unchanged (see chapter 2). These laws aided the discovery of electromagnetic waves (an example of which is ordinary light), relativity, and the quantum. They continue to serve as beacons in the present day.

Some implications of the work in classical electromagnetism (see chapter 6) remained unaddressed for almost two generations, until Albert Einstein's breakthrough theory of special relativity clarified our understanding of space and time and of mass and energy. Here again, ideas based in symmetry and conservation pointed to discovery (see chapter 7).

The physical laws of Isaac Newton were independent of relativism—that is, of the question of who was doing the observing. But that seemed not the case later, in the laws of electromagnetism developed by James Clerk Maxwell. Contrary to a widely held view in the community outside of physics, even today, Einstein's relativity theory demolished rather than promoted relativism in physics, which had seemingly surfaced in Maxwell's electromagnetism (see chapter 6). This realization ought to cut short cocktail party claims that Einstein's physics promoted relativism.

## SOME BASIC DIFFERENCES

The conviction expressed in this book that there are strong parallels between art and physics is not diminished by the recognition of some essential differences. Historical memory in art is impressed, either directly or subliminally, upon what follows. Also, the expressions of the mind and eye are bounded by the artist's sense of what "works" (about which more later). A host of considerations enter every phase of decision making along the path of artistic creation. Nevertheless, the constraints upon physical discovery have a different kind of rigidity.

New physical developments must be compatible with what is already known, make predictions consistent with the claims of the theory, and be falsifiable.[4] Mathematical bounds keep the language of testing precise. Newton's law of gravitation says not simply that two bodies attract each other but that the force between two masses is directly proportional to the product of the masses and inversely proportional to the square of their separation distance— and not, say, to the inverse of the distance to the power 1.9999. Its precise predictions apply equally to the apple falling from a tree and to the moon in its orbit about the earth.

Such requirements often are not sufficiently recognized. For example, the popular imagination has, understandably, been captivated by the new discoveries in the quantum microworld but has sometimes been enthralled by unjustified extrapolations from what is known. Physicists themselves have been partly to blame for such excesses.[5] Progress in lifting our perspective above fear and superstition has depended on the bounds that physics has placed on itself. The straitjacket that must be worn by physics is also its glory.

## BEAUTY AS GUIDE IN BOTH PHYSICS AND ART

No one doubts that making art is a creative activity. It is less commonly recognized that this is also true of the construction of a physical theory. The physical world offers no automatic path to discovery. About four hundred years ago the philosopher and statesman Francis Bacon emphasized the idea, uncommon in its time, that uncovering truth about nature must include direct appeals to observation.[6] But the necessary steps cannot depend on a willy-nilly collecting of data.

Gerald Holton, a distinguished contemporary physicist and historian of science, makes the important point that it is mistaken to view scientific thinking as dependent on an automatic process of induction.[7] A model of the physical world, sparked by creative insight, resembles a painting in which inspired strokes have guided the artist's brush.

The French physicist and mathematician Henri Poincaré wrote: "The [basic research] scientist does not study nature because it is useful to do so. He studies it because he takes pleasure in it; and he takes pleasure in it because it is beautiful . . . I mean *the intimate beauty that comes from the harmonious*

*order of its parts* and that a pure intelligence can grasp."[8] That aesthetic judgment guides great discoveries in physics can be appreciated from concrete examples, some of which we shall examine.

In commenting on his personal experience of beauty, computer scientist David Gelernter observed, "The sense of beauty is a tuning fork in the brain that hums when we stumble on something beautiful."[9] Artists and scientists know and cherish the experience of that hum. (The careful reader will recognize that Gelernter's statement, in context, is not really a tautology. He was expressing his personal recognition of a symptom accompanying his encounter with the beautiful.)

In their quest for coherence, artists and physicists, each from a distinct perspective, probe our inner and outer worlds and perceive meaningful pattern in a seemingly impenetrable forest of confusion. The results are profoundly rewarding, which explains why, throughout history, the arts and sciences have engaged humankind's aesthetic imagination. A more penetrating insight into both physics and art is gained when we allow them to be placed under the same lens. For example, artistic meaning is greatly affected merely by moving a cylinder in a David Smith abstract sculpture (see chapter 4). Analogously, the available quantum information about an electron confined to a box is strongly altered merely by changing the symmetry of the box (see chapter 3).

That same lens also reexamines some past efforts to connect art and physics. Contrary to occasional claims, particular aspects of the art of Edouard Manet and Paul Cézanne came from forces within art (see chapter 8), rather than somehow presaging trouble with physical ideas such as Newton's law of gravity. Another example: Analytical Cubism had no contemporary connection to Einstein's theory of relativity. Rather, a purely artistic purpose motivated the pioneering artists Braque and Picasso to compose their work as they did (see chapter 9).

We must cautiously appraise the mutual influences of art and physics but, at the same time, awaken to a new awareness: examining such seemingly unlikely connections broadens our understanding of how we make sense of the world.

# 2  What Is Saved and Why

The design principles and elements in visual art come from the testing ground of our direct visual experience. We learn to make sense of the visual road map when we discover clues based on hue, light and dark, shape, and a host of other cues that enter our consciousness. This is a subject for a later chapter. But what are some of those clues that help form our fundamental picture of the physical world, and how does one go about finding them? That is the job of the basic science we call physics.

## DESIGN ELEMENTS IN PHYSICS

It turns out that some of the keys to such understanding are what physicists call conserved quantities, that is, in plain language, those that are saved. They remain absolutely unchanging. This helps us to identify them and recognize their deep significance as crucial design elements in the physical world. Particular examples will help us understand the extraordinary insight provided by some of those keys.

Energy is an example of such a key. The conservation law for energy, a mantra we all learned in school, is that the total amount is conserved; it can be neither created nor destroyed. Despite the application of imposed changes, or *transformations,* the total amount in the system is conserved.

It would be hard to recognize that energy is a conserved quantity without knowing that what we have come to understand as energy can express itself in different ways. Recognition of the possible guises that can be assumed by energy came only slowly. For example, scientists did not fully grasp until the mid-nineteenth century that heat is a form of energy, corresponding to the random energy of motion of the microscopic particles of matter. Another such lesson came with the work of Einstein in 1905, as a by-product of his

special theory of relativity. The theory revealed that mass, an inherent property of material things, is equivalent to another energy form. This fact is expressed in the famous formula $E = mc^2$, where $c$ represents the speed of light, $E$ the energy, and $m$ the mass. The relationship between mass and energy applies even in mundane chemical reactions, as in the burning of a candle. The effect is more dramatically evident in nuclear reactions, which occur inside the cores of atoms, where the mass changes can be much greater.

A few of the faces energy can wear are on display in an ordinary greenhouse. The sun's light-energy passing through the glass interacts with matter in the greenhouse. Some becomes chemical potential energy in plants, leading to plant growth through photosynthesis. And some of the incoming light is re-radiated as longer wavelengths of radiant energy—for example, from visible light to infrared—after interacting with matter in the greenhouse. In all of these changes the total energy is conserved; it remains the same at the end of all of the conversion processes as at the outset.

Incidentally, unlike the entering, partially visible portion of the radiation, the glass is not transparent to much of the re-radiated, longer wavelength radiant energy in the infrared range and beyond. That radiant energy cannot pass back through the glass and ultimately contributes to further heating inside the greenhouse.

In the controversy concerning a possible greenhouse effect on the earth's weather, some scientists are concerned that excessive fossil fuel consumption could contribute to a concentration of carbon dioxide, along with other emissions, in the upper atmosphere. That gas layer would then purportedly serve a role analogous to that of the glass surrounding a greenhouse, trapping radiant energy and thereby contributing to a worldwide temperature rise.

Questions surrounding such an assertion are not diminished by the number of authorities marshaled on both sides of this argument. As this book is being written, a new political season is upon us, which serves to further energize the debate.

## OTHER CONSERVED QUANTITIES

Some of the other conserved quantities also show their effects ubiquitously. Consider *momentum,* which, for a material object, is the product of the mass

and its velocity. A collision between different objects changes their separate motions, like those of the billiard balls on a pool table, but what is not changed is the total momentum of an isolated system of colliding objects; it remains the same after a collision as before. A system is presumed to be isolated if outside influences, such as that of gravity, may reasonably be neglected.

Simple examples of momentum conservation for an isolated system are seen in the recoil of a rifle, the propulsion of jet aircraft and rockets, and the behavior of colliding billiard balls. For example, neither the rifle nor its contents are in motion before the trigger is pulled. And since there is no initial motion for the total system, the (reasonably isolated) system of rifle and bullet must continue, roughly, to have zero total momentum immediately after firing as before, so that total momentum will remain conserved. After the firing of the bullet, part of the system, the small bullet having great velocity, has moved forward. Thus, the relatively massive rifle is obliged to move backward; the forward momentum of the small but rapid bullet is cancelled by the backward momentum of the more massive but more slowly moving rifle.[1]

The same principle, the commitment to momentum conservation, causes a rocket or jet plane to thrust forward in response to the rapid backward motion of the ejected propellant. And that commitment does not, in itself, somehow reflect the clever design of the vehicle. Rather it is the inevitable expression of conservation of momentum.

You may know that radiation, which has identifiable physical effects in every aspect of our lives, also carries momentum and energy. It may seem unintuitive to recognize that the quantum of radiation, the photon, transmits momentum, but it does indeed do so.[2]

A quantity referred to as angular momentum is also conserved in an isolated system. The preservation of angular momentum includes maintaining the spin-axis direction, a property that is particularly useful in the operation of a gyroscope in guiding aircraft and space vehicles and in stabilizing ships at sea, a spinning football in flight, or an ice skater's spinning body.

The ice skater turning on the point of her skate may be assumed, roughly speaking, to be an isolated system: But for the contact "point" of one skate on slippery ice, she is effectively isolated from her surroundings. That her angular momentum is nearly conserved is demonstrated by the change of her spin rate as her arms are retracted or extended. When she draws her arms in, her distribution of mass becomes more restricted. So her spin rate must increase

to preserve the total angular momentum, which depends on both her spin rate and mass distribution.[3]

Given an isolated group of molecules, an isolated rocket ship, or, for that matter, an isolated galaxy of stars, the total energy, momentum, and angular momentum of the system will not change. If an isolated rocket should explode, for example, all of the component parts (matter plus radiation) would preserve their initial momentum, angular momentum, and energy. That some galaxies appear to violate conservation laws has suggested that they may not be isolated systems but instead are embedded in "dark matter." This subject is visited shortly.

## A LOOK AT SYMMETRY

Why are only particular physical quantities, such as energy and momentum, conserved? What makes them so special? After all, a familiar physical idea, that of force, has no such special status: The force applied by the hammer to a nail disappears. What does have staying power, of course, is the work-energy generated when the nail is driven by the force through a distance into the wood. Evidence for the energy produced is partially in the heating of the board.

When riding your bike, you learn the same lesson. Climbing the hill on your bike requires that a greater force be applied to the pedals. So you change gears to reduce the required force. But you may notice that, when doing so, you pay a compensating price by needing to pedal through a greater distance. It is the force times the distance that matters, both when driving the nail and when shifting the bike gears. And that force times the distance through which it is applied is equivalent to the energy expended. The point, in these examples, is that nature tends to the bookkeeping as it applies to conserved quantities, one of which is energy.

I have said something about what is saved but have not touched on why. What gives conserved quantities such special importance is that they are associated with particular symmetries. To under-

Figure 1. A symmetrical vase

stand this connection, one needs first to make a brief excursion into the nature of symmetry.

The term *symmetry* commonly suggests the conformation of parts and balance. In a simple example, most of us would readily judge the vase shown in figure 1 to be symmetrical. One might say that, if you rotate the vase about the indicated axis (the dotted line), the appearance of the vase remains unchanged; the vase is symmetrical under rotation about that axis. A sphere exhibits an even greater rotational symmetry, for the appearance of the sphere is preserved no matter which rotation axis passing through the center point is chosen.

Here you have a clue to the general idea of symmetry. It says, in effect, that if something remains the same under a particular change, or transformation, imposed on it, there is an associated symmetry. Notice that the vase has mirror symmetry as well, for the images on both sides of a vertical plane through the axis are identical.

Mathematicians have found it useful to get closer to the heart of judgments like this, systematically exploring symmetries of objects such as crystals and the configurations of atoms within them. The resulting discoveries have had a profound effect on the understanding of our physical world.[4]

But our interest here is in symmetry expressed by physical law itself, for example, Newton's laws of motion and the conservation laws we have mentioned. The question is, then, what changes, or transformations, can be imposed on physical laws that allow those laws to remain the same? You expect them to be the same wherever your laboratory is located, in whichever direction your apparatus is turned, and whenever the experiment is performed. It would seem strange indeed if changing the position or the direction or the time of measurement affected basic information about the physical world.

At first encounter, it seems astonishing that these transformations—shift of position, direction, and time—correspond to the conservation laws for momentum, angular momentum, and energy. But that is the case!

- It is mathematically demonstrable that the conservation of momentum is a consequence of spatial symmetry, that the laws of physics remain unchanged under spatial transformations. Shifting of experimental test apparatus from one point in space to another has no effect on tests of the physical law—and this fact corresponds to the fact that momentum is conserved!

- Similarly, conservation of angular momentum corresponds to rotational symmetry in space; physical law remains the same under transformations of direction in space.
- Finally, conservation of the total energy in a system corresponds to time symmetry. Transformation from one time to another does not change physical law, which was the same in 1066 as in 1492 and in 1776.[5]

These deep connections may strike you as strange indeed. And most students of physics, on first encounter, would agree. The fact that we can prove them in a few lines of mathematics does not dull the sense that such realizations are quite a kick.

A general mathematical theorem, called Noether's theorem, states that all *continuous* transformations correspond to conservation laws. Translations, rotations, and time shifts are examples of continuous transformations. In classical physics, there is no tested, observed limit to the minuteness of conventional shifts in position, angle, or time; these shifts are continuous, not discrete. Noether's theorem, which formalizes those connections, continues to have a powerful role in guiding discovery in the forefront of research, ranging from that on elementary particles to cosmology.

We all can be thankful for the progress in tolerance that has been attained in many countries over the past few generations. Owing to her sex and ethnicity, the distinguished mathematician Emmy Noether (1882–1935) had great difficulty obtaining permission in Germany to pursue her higher studies and engage subsequently in scholarly activities, despite the intercession on her behalf by David Hilbert, one of the greatest mathematicians of his time. In 1933 she escaped Nazi persecution by immigrating to the United States. She took a visiting professorship at Bryn Mawr College until her premature death a few years later.

## CONSERVATION LAWS AND THE NEUTRINO

A strange subatomic entity, which came to be dubbed the neutrino, was predicted theoretically before it was discovered experimentally. And its unlikely prediction, in conflict with what at the time seemed eminently common-sense reasonableness, illustrates some of the power of the conservation laws and their associated symmetries in guiding discovery.

The core of an atom, its nucleus, contains most of the atom's mass in a space occupying only a minute fraction of the atomic volume. The radius of an atom is roughly $10^5$ (one hundred thousand) times greater than that of the nucleus. The nucleus is made of the neutrons and protons. In some nuclei, spontaneous radioactive decay occurs. In an example of such a process known as beta decay, an electron is emitted along with other products, and a neutron is changed to a proton.

What especially disconcerted physicists about beta decay was its apparent violation of the conservation laws of energy and momentum. In the face of such evidence accumulated by 1930, physicist Wolfgang Pauli put forward what seemed at the time a fantastic notion. He proposed that a hitherto unknown and seemingly undetectable particle is also emitted. But, to be consistent with the basic conservation laws, the particle would have to have strange properties indeed: no electrical charge and very small—perhaps zero—mass.

In 1934 Enrico Fermi, calling the proposed particle the *neutrino* (little neutral one, in Italian), developed the hypothesis of its existence into a comprehensive theory. The theory produced a disconcerting prediction: If it actually existed, such a particle would have virtually negligible interaction with matter. The calculations showed that the hypothesized neutrinos could, with high probability, travel through a light-year thickness of solid lead without being stopped! (A light-year is the distance light travels in a year, about $6 \times 10^{12}$ miles, or six thousand billion miles.)

But the inviolability of the conservation laws was so firmly based that the possibility that such a ghost particle actually existed was not dismissed out of hand. The heroic experimental search by Clyde Cowan and Frederick Reines bore fruit in 1956. And the discovered particle (now labeled the electron antineutrino) had the very properties required for preservation of the conservation laws that had seemed to be violated in the beta decay process. Reines was a corecipient of the Nobel Prize in 1995. Cowan, who died in 1974, could not be considered for sharing in the honor, since the Nobel is not awarded posthumously. Several kinds of neutrinos are now known.

A sequel to the story concerns a present-day mystery in physical cosmology, which includes the study of the large-scale physical structure and evolution of the universe. It appears that the light that stargazers and astronomers have been gazing at all this time represents only a small portion of the matter

in the universe. It is now estimated that the remaining matter is undetectable by present methods. Called *dark matter,* its nature is currently unknown.

Incidentally, new evidence suggests that the total amount of matter, visible and dark, is dwarfed by a mysterious ingredient, the nature of which is also currently unknown. Inferred from the accelerating expansion of the universe, it is called *dark energy.*

## DARK MATTER

The imagination and our sense of wonder have, throughout history, been kindled by the nighttime sky and its hidden meanings. The ancients appealed to mythology in their attempts to understand the shapes they imagined in the constellations. And it is no wonder that several of our major religions were born under the clear desert skies of the ancient Middle East. While our current urban night skies offer far less inspiration, many of us still shudder in awe on first seeing the brilliant blanket of stars in a desert sky.

Stargazers for thousands of years have attempted to learn from the stars. Modern instruments have extended the reach of our eyes, and this new vision

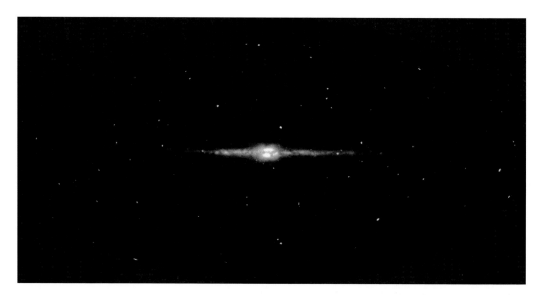

Figure 2. The Milky Way Galaxy. From its orbit around Earth, the Goddard Space Flight Center's Cosmic Background Explorer (COBE) captured this edge-on view (looking toward the center) of our Milky Way galaxy in infrared light. (NASA)

has served only to increase our awe at the apparently inexhaustible surprises that continue to be uncovered. But there was no inkling until well into the twentieth century that most of the matter out there may be in the form of a dark cocoon enveloping what we have understood to be, at least in principle, the directly knowable universe.[6]

One of the clues that dark matter actually exists comes from observations of galaxies, massive island clusters of stars, interstellar matter, and radiation. Let us take a moment to look at galaxies before returning to the question of how their behavior betrays the existence of dark matter. An example is our own Milky Way (from the Greek, for galaxy), consisting of some hundred billion stars, one of which is our Sun. When you look overhead into the dark night sky and see the Milky Way, a broad avenue of densely packed stars, you are actually seeing in rough cross-section some of our own galaxy. Observations reveal that our solar system is in one of the spiral arms of a huge, spinning disk of stars, about two-thirds the distance from its bulging center. The center of our galaxy is probably the home of a huge black hole, a celestial object so dense that even light cannot escape its gravitational pull.

To turn once around its central bulge, the great merry-go-round of our own massive island of stars, our galaxy, takes more than 100 million Earth years, an Earth year being the time needed for the Earth to go once around the Sun. Since we are well within our galaxy, it is impossible to completely pictorially frame our great island universe, with its 100,000-light-year diameter, but figure 2 shows an edge-on view from well inside our galaxy, recorded by its near-infrared light.

As late as the 1920s, astronomers believed that our Milky Way Galaxy was the entire universe, but now they are aware of some hundreds of billions of other galaxies. Andromeda, our nearest comparable galactic neighbor in space, about 2.5 million light-years away, is a spiral galaxy believed to be similar to our own (figure 3).

The Hubble Space Telescope in orbit about the earth has captured remarkable celestial photos, among which is the Hubble Ultra Deep Field image (figure 4), showing previously unknown galaxies at a great distance from the earth. Here the Hubble space telescope has captured galaxies estimated to be 5 to 10 billion light-years away. Since our solar system itself is estimated to be less than 5 billion years old, the light from some of those galaxies started its journey before the earth existed.

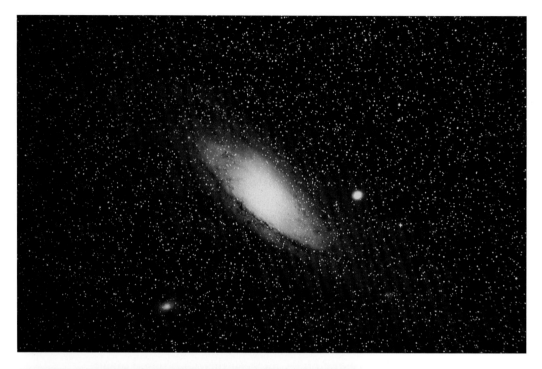

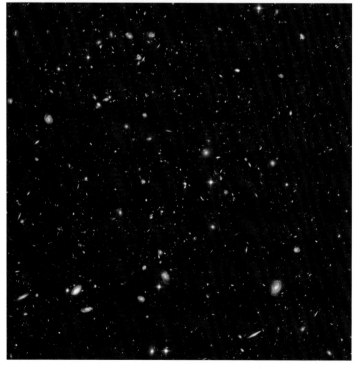

Figure 3. The Andromeda Galaxy. (NASA Marshall Space Flight Center)

Figure 4. The Hubble Ultra Deep Field. (NASA, ESA, and S. Beckwith [STScI] and the HUDF Team)

The light from the most distant galaxies captured in figure 4 is so dim that million-second-long exposure was required: 800 exposures with an average exposure time of 21 minutes. At the same time, the image was like a deep-core sample of a minute area of sky, the farthest reaches of the core sample representing the most distant galaxies in the view, which captured some ten thousand galaxies. The minute angle sampled has been likened to looking through an eight-foot-long soda straw. Clearly, the camera pointing problem was immense.

Modern observations have revealed that galaxies are clustered on a grand scale, bound into groups of a few thousand. These clusters, in turn, appear to be part of super-families, enclosing huge voids and stretching web-like across vast regions of the cosmos. These expanses of matter in our universe are postulated to derive from an earlier symmetry, a formlessness and homogeneity in the early period after the postulated big bang. This is fortunate indeed for us; without that descent from symmetry, the development of "broken symmetries" as indicated in the currently observed agglomerations of matter, our very existence would not have been possible. (The crucial role of broken symmetries, resulting from all physical processes, is touched on in the next chapter.)

Return now to how the existence of dark matter is suggested by galactic observations. As a clue to one of those ways, astronomers have discovered that the rotation velocities of galaxies do not show an expected decrease with distance from their centers. As one possible explanation, evidence suggests that those galaxies may be embedded in other gravitating matter that is not observable, the so-called dark matter referred to earlier. While evidence of dark matter was suggested in the 1930s by Fritz Zwicky and Sinclair Smith, that work received little notice.[7] The modern search for dark matter may be said to have begun with some observations of star motion in our neighboring galaxy, Andromeda.

The measurements by Vera Rubin and Kent Ford, first reported comprehensively in print in 1970,[8] reopened the likelihood that most of the mass in the universe is not visible. It is as though, all through the ages of human observation of the heavens, people have been admiring a few scattered jewels while remaining oblivious to the black velvet cloth in which they are suspended.

Rubin had set out in the 1960s to determine how the orbital speeds of stars in Andromeda, also known as M31, varied with distance from that galaxy's center. Since the visible mass is largely concentrated about the massive cen-

tral bulge of the galaxy, star velocity is expected to decrease as distance from the center is increased.[9]

Painstaking measurements reported in the 1970 paper by Rubin and Ford showed, surprisingly, that this was not the case. They reported that, over a wide range of measurements extending well outside the visible disk of Andromeda, the orbital speeds of stars remained essentially the same with increasing distance from the galactic core. The evidence indicated that there was invisible mass extending well beyond the detectable limits of Andromeda.[10] Other spiral galaxies have also been studied in the search for dark matter.[11] More recent astronomical observations have further supported the existence of dark matter.

Astrophysicists and elementary particle physicists are actively attempting to determine the nature of the hypothesized dark matter. Among the candidates for dark matter is the neutrino (currently only a dark-horse candidate), for there is now experimental evidence that the neutrino, formerly thought to be massless, indeed has a small mass. Current theory points to other suspects, such as hypothesized particles labeled WIMPS, standing for weakly interacting massive particles.[12]

Whether or not it remains a dark-matter candidate, the neutrino has come to be recognized as an absolutely essential part of the structure of modern physics. It is fascinating that a particle such as the neutrino, postulated against reason, save for the compelling impetus of the conservation laws and their associated symmetries, should have come to have such importance.

# 3 What Is Broken and How

## A FISH IN A BOUNDLESS AND FEATURELESS SEA

Imagine a fish immersed in a boundless and featureless sea. The fish would be oblivious not only to rotations imposed on it or the surrounding medium but also to shifts in position (translation). Without a reference point and meaningful sensory input, the fish would experience a vast sameness, a numbing environment precluding its ability to function. Here would be a profound symmetry, one like the blank canvas confronting the painter before he has placed the first brush stroke.

Recall that a central attribute of symmetry is constancy despite an imposed change, or transformation. Chapter 2 showed a deep symmetry indeed: the persistence of physical law itself under transformations. This symmetry requirement is among those useful in testing proposed physical laws and helping guide the discovery of new ones.

Newton's laws of motion and gravitation and the conservation laws were the same for the invading Normans in 1066 as for the Allies storming Omaha Beach, on the opposite side of the English Channel, on D-Day in 1944. It may strike us as self-evident that this is how things should be. But is it necessarily how they must be? Why must we be spared a physical world without order and meaning? Einstein was awed by the question.

One can say: the eternally incomprehensible thing about the world is its comprehensibility . . . One could, even *should,* expect that the world turns out to be lawful only insofar as we intervene to supply order. It would be the sort of order like the alphabetic ordering of words of a language . . . But Newton's Theory of Gravitation is of a quite different character . . . The success of such an enterprise does suppose a high degree of order in the objective world, which one has no justification whatever to expect

*a priori.* Here lies the sense of "wonder" that increases ever more with the development of our knowledge.[1]

It is undeniable that the stubborn belief of pioneer scientists like Einstein in a meaningful world has guided some of their greatest discoveries.

## BREAKS FROM SYMMETRY

A small number of physical laws and their associated symmetries preside over natural processes. In turn, natural processes, such as the splash made by a stone when breaking the surface of a pond, are associated with *broken* symmetries. Broken symmetries are what make for the rich experience of the world, and they occur spontaneously as an unavoidable by-product of natural phenomena.

Formerly hidden information is revealed when a symmetry is broken. A small example is to attach a handle to the vase mentioned earlier. This reduces its former rotational symmetry and reveals the information that, for most angles, there has been a rotation of the vase (figure 5).

A bubble or a strand of seaweed permits the fish in that once featureless sea to establish a sense of direction and place. And from the array of further stimuli in its surroundings, the creature is able to recognize ingredients necessary for it to thrive. Its world takes on meaning only after form and matter begin to fill the void in which the fish finds itself. As more forms appear, it must find among the bounty of stimuli those that hold promise for its survival.

A strange parallel occurs in the creation of a work of art or a physical theory. The artist confronts the sterile symmetry of the blank canvas or the uncut stone. The challenge is delivered when the first brush strokes break that symmetry and artistic information enters the scene. The artist must replace that initial balance, sterile though it may have been, with a new one. But now the balanced statement,

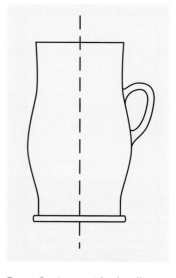

Figure 5. A vase with a handle

comprising an array of artistic elements, is expected to be rich in implication and internal coherence if it is to satisfy successful composition.

Analogous examples occur commonly in physics. It seems remarkable that a relatively small number of physical laws and their associated symmetries give rise to the vast diversity in our universe. Take the case of a droplet falling into a saucer filled with the same liquid. One generally observes that the original high symmetry of the droplet has been transformed into a more complex splash pattern. The splash may form a regularly arrayed, spiked crown pattern as it rises from the liquid surface. (This was famously shown in flash photographs made a half-century ago by Harold Edgerton.) The splash has lower symmetry than has the droplet: only for certain angles do you see rotational symmetry for the spiked crown. The symmetry has been broken.

How did it happen that the symmetry was broken? What happened to the symmetry in the earlier pattern, that of the droplet? A persisting, *circular* splash pattern for the wall of liquid is, in principle, a possible result, one of the mathematical solutions of the problem. But it is unlikely because it is only one of an array of possible outcomes.[2] That is the crux of the matter.

Imagine identical beads of two different colors in a glass jar. While the colors (say, red and white) may have been carefully separated at the outset, the process of shaking the jar will result in mixing of the beads having the two different colors. It is possible but not probable that, on repeated shaking, the red and white beads will again become separated as before. Here is symbolized the idea of entropy, which says essentially that processes increase the disorder of systems.

In another example, it is possible but extremely unlikely that the huge number of air molecules, in highly rapid and random motion in your room, will for any significant time find themselves in a particular corner. The reason is that there are a huge number of possible positions for each of the rapidly and randomly moving particles. There are, in every 25 quarts of air in the room, about $10^{24}$ molecules moving randomly at an average speed of several hundred miles per hour.

The possible examples are virtually limitless. In figure 6, the ball had been perched precariously on the sharply peaked bulge at the bottom of a bowl, so that the slightest disturbance would cause the ball to fall to one of the possible lowest positions, thereby breaking the initial symmetry. If the experiment is prepared ideally, the ball can fall to a lowest point anywhere in the 360° range

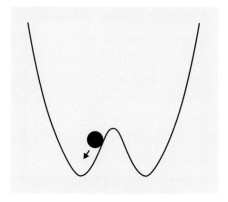

Figure 6. A sharply puckered bowl

of possible final positions with equal probability. Such broken symmetries are part of everyday phenomena. They occur spontaneously as an unavoidable by-product of natural processes and contribute to the rich world of experience available to us. Both artists and physicists seek coherent pattern buried in a seemingly chaotic array of disparate stimuli.

Some broken symmetries occur out of sight, as violations of so-called internal symmetries, primarily of concern to nuclear and elementary particle physicists.[3] While it does have bearing on the question of charge conservation, treated in chapter 7, the subject is not generally relatable to the visible world shared with art and therefore would represent a diversion from our purposes.

## THE EVOLVING COSMOS AND SYMMETRY BREAKING

Astrophysicists and particle physicists postulate that the vast structures illustrated in chapter 2, agglomerations of matter on unimaginably vast scales, emerged from a homogeneous beginning. Study of the physical properties and evolution of the cosmos suggests that, while the very early universe may well have expressed a deep symmetry, symmetry-breaking processes are responsible for the existence of the large-scale and small-scale structures now witnessed through our telescopes.

Evidence from particle physics and astrophysics provides a rather well-supported "*near* the beginning" story. About 14 billion years ago, the temperature in the universe was $10^{15}$ degrees, too high for matter to form. At such temperatures, a homogeneous mix of radiation, matter, and antimatter particles were in continuous interchange. With cooling to about $10^{12}$ degrees just a few minutes later, accompanying the expansion of the universe, matter particles could remain separated from the light: radiation no longer had sufficient energy to participate in the continuous interconversion between matter and radiation. Matter and antimatter mutually annihilated, leaving the equiv-

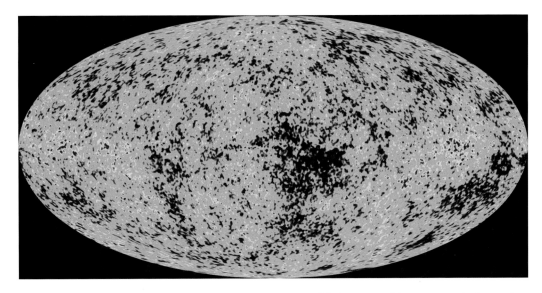

Plate 1. The Wilkinson Microwave Anisotropy Project (WMAP) full-sky image of the microwave background

alent energy as radiation. Why some matter was left after that mutual anni-
hilation is still not well understood, but it was fortunate for us. The physicist
Andrei Sakharov proposed in 1967 a set of necessary conditions for this to
have happened.[4] With further cooling to a mere billion degrees, nuclei of the
light elements formed from the surviving matter particles. Further cooling was
necessary, to an estimated 3,000 K (Kelvin), before atoms could be bound
together. Then gravitation came into play sufficiently for the formation of gal-
axies and stars and for the processes required for the appearance of the heavier
elements—and, ultimately, our solar system and our earth.[5]

The label *big bang* is somewhat misleading, for it isn't intended to sug-
gest an explosion from a particular place and time. Rather, it refers to a con-
tinuous, ongoing expansion involving the entire universe. New evidence
strongly supports the big bang theory, which includes an early inflationary
expansion. The microwave energy filling all space has been surveyed in great
detail in WMAP (Wilkinson Microwave Anisotropy Project) (see plate 1).
Analysis of the measurements, reported in 2006, provides strong evidence for
the current big bang model for the evolution of the universe. The microwave
spectrum, showing the dependence of the intensity of the radiation on the
wavelength of the microwaves, follows exactly what would be expected of a
cooling universe.

A coal fire, approximating what physicists refer to as a black body, changes color on cooling. For any given temperature, the black body displays a spectrum of wavelengths, with the range of wavelengths becoming longer as the temperature is reduced. The observed radiation pervading space corresponds to a present temperature of 2.73 K (about 270 degrees below zero on the centigrade scale). The corresponding spectrum of wavelengths falls in the microwave range, many thousands of times longer than that of visible light.

Scientists once wondered how matter could clump into the now visible structures without there being, at that time, evidence of inhomogeneity. The recent analysis of the measured distribution of minute fluctuations in temperature (ranging over only 2 parts in 10,000 K) is consistent with details of the theory.[6] The fine-grained structure now evident in the measured microwave background is consistent with the clumping of matter in the universe.

The four distinct forces now known may have been undifferentiated in the very early universe. As the universe expanded and temperature fell after the postulated big bang, the symmetry was broken, giving rise to the separate forces known today from what had presumably once been a single, unified force. The *electromagnetic* force governs the interaction of electrically charged particles. The *strong* force operates in the atomic nucleus. The *weak* force is expressed, for example, in radioactive decay processes in atomic nuclei. And the familiar *gravitational* force describes the mutual gravitational attraction of masses. Theory has already established the linkage of the weak and electromagnetic forces. Progress has also been made in showing connection with the strong force.

This evolution to the present distinct forces may be regarded as very remotely analogous to familiar *phase changes*. Take, for example, the transition of water vapor, which appears to be rather homogeneous on the large scale, to other forms, which appear as temperature is reduced: the molecules form an ever closer association, forming first liquid water (the liquid phase) and then the solid phase (ice). Notice that, when compared to the water phase, the ice crystal has lower symmetry. It has a reduced rotational symmetry: As the crystal is rotated, the appearance of the crystal is altered. With each successive change of phase from vapor to liquid water to ice, the symmetry is reduced.

The instability against change of phase to lower symmetry is evident even in the boiling and freezing of water: Water that has been carefully prepared

so as to be free of impurities and suspended particles can be "super-cooled" and not freeze at its usual freezing temperature (0 degree C, or 32 degrees F, at sea level). If a small perturbation is introduced, perhaps a grain of sand or salt, the water may then immediately freeze.

## THE FAILURE OF MIRROR SYMMETRY IN NATURE

Figure 7 illustrates one of the mirror symmetries of a cubic solid. The images on both sides of the "mirror plane" are identical. Another example is the perfect reflection of a shore scene and its image on an undisturbed water surface: Which is the object and which the mirror image? Such an absence of information is an example of mirror symmetry.

An excellent example of a broken symmetry—and the associated liberation of information—is the breaking of mirror symmetry, or right-hand/left-hand symmetry, in elementary particle physics. If you wanted to transmit to a being on a distant planet what humans look like, you could send lots of information using universally understandable language. Multiples of the wavelength of light could be used to express given lengths, and atomic spectra could transmit information about the atomic and molecular makeup of matter here on Earth. But what physical property would you use to tell that creature about something as seemingly simple as which of our hands is the right?

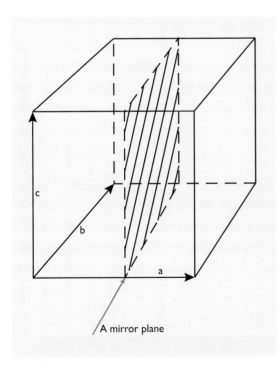

Figure 7. A cube, showing a mirror plane. Sides *a, b,* and *c* all have the same length and are mutually perpendicular.

None of the more familiar physical processes allow a right-hand/left-hand distinction. This means simply that one cannot tell whether the thing itself or its mirror image is at work. Here again, then, is an example of a symmetry representing denial of information, an unobservable.

It had long been felt that mirror symmetry is observed in physical phenomena without exception, that it is a law of nature. Processes depending ultimately on the electromagnetic, the nuclear, or the gravity force do indeed obey mirror symmetry. So you cannot appeal to any such process in conveying to that intelligent being on a distant planet the sense of right-left.

The situation changed in 1956, with confirmation of the prediction made by two theoretical physicists, T. D. Lee and C. N. Yang, that mirror symmetry would be violated in the case of one of the four known forces, the "weak interaction" force in physics.[7] As already noted, these are responsible for processes such as radioactive decay of some atomic nuclei and the release of energy from the sun and the other stars. The confirmation of the breaking of mirror symmetry in weak interactions led to Nobel prizes for Yang and Lee, the physicists who had predicted it.

C. S. Wu, E. Ambler, R. W. Hayward, D. D. Hoppes, and R. P. Hudson experimentally verified the prediction by studying the decay of radioactive cobalt ($^{60}$Co), where an electron and an antineutrino are emitted in the decay process. In effect, two separate arrangements of the cobalt nuclei were compared. Each had their nuclei oppositely oriented with aid of appropriate magnetic fields and very low temperatures to minimize thermal agitation and consequent de-orientation of the nuclei. That is, the two configurations of the nuclei were mirror images of each other. Nevertheless, the electrons emitted from each of the two groups of nuclei were not mirror images of each other.

A careful study of the electron "spin" showed that the emitted electrons from both set-ups behaved like left-handed screws! The mirror image of a left-hand screw is a right-hand screw, as you can see in figure 8. But the spin of the emitted electron is a left-hander. The spin referred to here is a quantum mechanical property, inseparable from the particular particle. In a magnetic field, the electron can be caused to rotate in a manner suggestive of ordinary rotation with which we are familiar. But the spin referred to above is an inherent, quantum mechanical property of the electron. It is only remotely analogous to the meaning of that word in its everyday context, suggesting toy tops and rotating windmills.

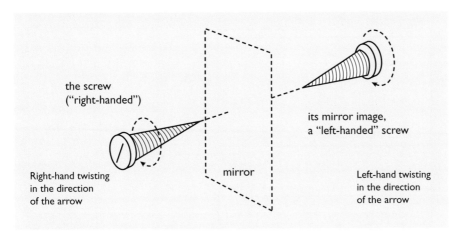

the screw
("right-handed")

its mirror image,
a "left-handed" screw

Right-hand twisting
in the direction
of the arrow

mirror

Left-hand twisting
in the direction
of the arrow

Figure 8.  A screw and its mirror image

Here, then, is a violation of right-hand/left-hand, or mirror, symmetry. Since the liberated electron's spin preserves the character of a left-hand screw, you now have a way of unambiguously identifying right and left for that little being on the far-away planet. The breaking of mirror symmetry in this weak interaction process reveals otherwise denied information.

## UNOBSERVABILITY AND CATCH-22

The closed box in figure 9a represents a closed system, within which you may want to apply *classical* conservation laws. Such isolation is necessary, in principle, since only in the closed system are the conservation laws and their associated symmetries strictly observed. In the figure, the double walls signify that the contents of the box are secreted from the outside world, with the "excluded eye" symbolizing the unobservability condition for the outsider.

Here is an apparent Catch-22.[8] For the conservation laws to be strictly valid, an isolated system is needed, one from which outside influences are excluded. Yet the conservation laws are invaluable in making sense of observations, as we saw exemplified in the history of the neutrino prediction and discovery. How can the observations be compatible with the requirement that the system be isolated?

For useful information to be obtained, the processes being examined must be negligibly disturbed in the course of measurement. That the interaction

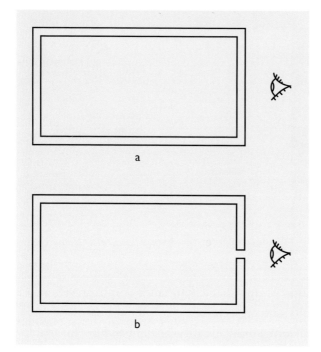

Figure 9. A closed system *(a)* and a slightly open one *(b)*

must be negligible is symbolized in figure 9*b* by making only a small open-ing in the box. But how small is small enough depends on the particular sit-uation. For example, in measuring electrical effects in the laboratory, one may generally neglect the influence of gravity (which cannot be fully excluded), since the electrical force between a pair of electrons is about $10^{40}$ times greater than the gravity force. But there are limits to such assumptions of negligible interference.

## THE STRANGE QUANTUM WORLD

The last comments, viewed from the point of view of classical physics, impinge on a central issue one confronts directly in the world of atoms and subatomic particles. Although the laws of Newton's mechanics are sufficient to describe the everyday world of common experience, quantum mechanics governs behavior in the domain of the very small. Much of that behavior is very surprising. This is exemplified by the Heisenberg uncertainty principle,

which sets quantitative bounds on our ability to determine certain pairs of physical quantities simultaneously.

If you should want, for example, to know both the position and momentum of an electron, the Heisenberg principle sets concrete limits on the ability to determine them at the same time. The minimum uncertainty in that determination involves a quantity, ubiquitous in the quantum domain, known as Planck's constant, symbolized universally by the letter $h$; the uncertainty can never be reduced to zero. Further, rather than display a continuous flow, energy exchanges in an atom can occur in "lumps," or *quanta;* the energy levels are "quantized."

Both radiation and matter can express either particle-like or wave-like behavior but not both simultaneously; an experiment can demonstrate either the particle-like or the wave-like aspect of an electron or a quantum of radiation, the photon. For either, the particular feature to be displayed, particle-like or wave-like, is determined by the observational stage set by the supposedly noninterfering observer. It is as though the electron or the photon responds accommodatingly to the particular question posed by the experimenter in designing an experiment. "You are a particle, are you not?" Answer: "Yes, indeed I am." "You are a wave, are you not?" Answer: "Yes, indeed I am." But even these admittedly cryptic comments do not begin to wrap themselves around the peculiarities of photons and electrons when we come into their world armed only with our everyday, "real-world" perspective.

Let us start with an experiment originally introduced to show that light is a wave. In Newton's time, there raged a debate about the nature of light. Newton insisted that it consists of particles, while an opposing position, championed by a contemporary of Newton, Christian Huygens (1629–95), supported a wave description. It is strange that those classical arguments, reshaped, have a kind of resonance in the current quantum picture.

Thomas Young, a polymath (physicist, physician, linguist, Egyptologist) who lived from 1773 to 1829, conceived of an experimental test he hoped would settle the point. The experiment was based on the way waves interfere with each other. Many of us have seen interference between a pair of wavelets set in motion when two stones are tossed into a quiet pool; each wavelet sets up a series of expanding circles, and where the separate circles overlap in step, you see a larger peak. Young arranged for a monochromatic light beam to impinge on a barrier having an opening arranged as a closely spaced pair of

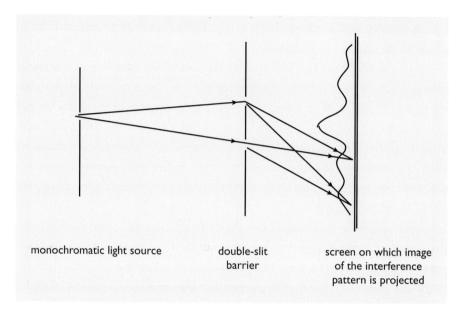

monochromatic light source

double-slit
barrier

screen on which image
of the interference
pattern is projected

Figure 10. A schematic diagram of an interference experiment with light

slits. The light coming from the double slits then illuminated a screen. The image on the screen showed an interference pattern: bright regions appeared where the two separate light waves from each of the two separate slits recombined on the screen in step, but no light where they landed exactly out of step. Young's experiment seemed to prove that light is a wave. The kind of pattern that appears on a screen, a pattern of alternating light and dark regions, is shown schematically in figure 10. The wavelets emanating from each opening are not shown.

The twentieth century opened with the discovery by Max Planck that energy is emitted and absorbed by matter in packets. It is emitted not in a continuous flow of energy but in discrete amounts, that is, in integer multiples of wave frequency $f$. So, for a given value of $f$, energy $E$ can equal $hf$, $2hf$, $3hf$, and so on. Here, Planck's constant $h$, which we saw earlier, is a fundamental constant of nature that crops up ubiquitously in quantum mechanics.

Albert Einstein showed five years later that the packets of energy cited by Planck can be viewed as traveling particles of radiation, which explained an experimental observation known as the photoelectric effect. The model was reinforced when Karl Compton later showed that these light quanta behave

like particles in scattering experiments. So light may be viewed as consisting of packets of energy, the quanta now called photons.

Young's experiment now can be examined in new light. (Forgive the pun.) One can envision the light incident on the double slits as a beam of particles. But if that is the case, then what happens when the number of photons is reduced so much that only individual photons impinge on the double slits? One should, from the classical physics point of view, reason that the photons would behave like bullets. That is, they would be expected to go through one slit or the other, making two distinct marks on the screen, following a path allowed by the two slits.

The experiment has been done. When you let one photon at a time go to the target, what finally is observed turns out to be the same interference pattern found by Young! What is more, the separate photons, in going through the slits, land in ways, one by one, that do not seem to follow a definite pattern until many impressions have been made on the screen, finally revealing an interference pattern. What conclusion can be drawn from this? It is as though each photon goes through both slits and recombines with itself after going through, thereby allowing an interference pattern to form.[9]

But what happens when a matter particle (i.e., a particle with mass such as an electron or proton) is put through the same hoops? Prince Louis de Broglie made a key proposal, for which he received the Nobel Prize in 1929. He asserted that a wavelength is associated with the momentum of an electron and that this wavelength is equal to Planck's constant $h$ divided by the electron's momentum. This assertion has been amply demonstrated in a wide range of experiments.

Why aren't the wave-associated properties of matter commonly observed in our lives? We have no doubt where a cow is; its image is not fuzzy. The answer is that even the wave associated with a slowly moving grain of sand is far below our perception. Let us look at that.

Recalling that the de Broglie wavelength is equal to Planck's constant divided by the particle's momentum, what is the de Broglie wavelength of even a slowly moving grain of sand? If you take the mass of the sand grain to be a microgram and the speed as only a tenth of a centimeter per second, the de Broglie wavelength of the sand particle is still only about $10^{-12}$ the size of an atom and, very roughly, about $10^{-18}$ (a billionth of a billionth) the size of the grain of sand. Clearly, we do not experience such quantum phenomena in our daily lives.

It has been a tall order to attempt Young's interference-type experiment to demonstrate electron-wave interference. Practical electron sources emit electron wavelengths that are orders of magnitude smaller than that of visible light, and such small wavelengths require that the slit spacing be comparably reduced. A double-slit electron diffraction experiment was done in 1961 by Claus Jonssen. Merli et al. performed the experiment with a single electron at a time going through the slits in 1976. And in 1989, using especially sophisticated techniques, A. Tonomura repeated the electron double-slit experiment, again with one particle at a time passing through the slits.[10]

Remarkably, the result was like that of the photon experiment. When the electron beam intensity was reduced to permit only one electron at a time to pass through the double slits, an interference pattern resulted. Each blip on the screen, recording a single electron, landed without obvious pattern. But, gradually, what developed was a wave interference pattern.

Quantum mechanics is one of the most quantitatively successful theories in physics. Physical understanding in quantum mechanics has led to the demonstration of beautiful and truly unanticipated phenomena and to physical applications from medical lasers to nanotechnology. Although the experimental expressions of quantum phenomena are well confirmed, there is not universal agreement among physicists on their possible interpretations. The Copenhagen school of quantum mechanics, led by the physicist Niels Bohr in the first half of the twentieth century, was comfortable with wave-particle duality. The Nobel laureate Steven Weinberg and some others believe that a more satisfactory understanding will require that both the observer and his laboratory measuring instruments, now described classically, ultimately must be represented in quantum mechanical terms, along with the object of their investigations. Such an ambitious project lies in the future.

The fascinating quantum microworld is unlike the everyday world we know; it is not possible to carry over quantum analogies to the domain of our common experience. Misunderstanding of the scientific basis of quantum mechanics, what it says and what it doesn't say, has led, in the public mind, to unfortunate extrapolation unsupported by scientific scrutiny via carefully controlled experimental study. Such behaviors are easy to understand: revelations about the quantum have captured the imagination for over a half-century. But certainly these gifts of knowledge do not deserve to be diminished by misleading fictions or undemonstrated claims. The bounds imposed in

physics include the requirements of testing, consistency with known facts, and the requirement of falsifiability. That is, a scientific claim must be capable of being shown to be false. Such limitations put constraints on excessively romantic extrapolations. Speculation has a role at the active forefront of research, but even physicists often find themselves reminding each other that inherently untestable flights of fancy cannot be the endgame.

## INFORMATION FROM AN ELECTRON IN A BOX

Having opened the quantum Pandora's box ever so slightly, we may now turn to a simple lesson from quantum mechanics that has direct application to our theme of symmetry and denial of information versus the breaking of symmetry and the liberation of information. Imagine an electron confined to a box but able to move freely inside it. The energy of the electron in the box is *quantized,* restricted to specified, discrete values. In a homely metaphor, the situation is roughly analogous to that of an auto in a parking garage, where the car may legally be parked only on discrete floors of the garage and ramp parking between floors is forbidden. The higher floors represent higher energy levels, as evidenced by the energy needed to reach them as well as the energy that would be released if a car were to come crashing down to the ground from one of those floors.

The particular energy state of the electron is identified by assigning three quantum numbers to it. A fourth, the spin quantum number, describing the intrinsic quantum mechanical spin referred to earlier, need not be considered here. It may happen that the energy state of the electron in the box is not uniquely specified by the quantum numbers. In that case, the state of the particle is said to express energy degeneracy. One possible cause for such ambiguity is high symmetry of the box.

For concreteness, consider the cubical box shown in figure 7; the sides, labeled *a, b, c,* are all of the same length and are mutually perpendicular. A cubical shape displays a high level of symmetry, as evidenced, for example, by the fact that the cube shows rotational symmetry about several axes; rotations about those axes turn the cube into itself. Further, there are several mirror symmetry planes, an instance of which is shown in figure 7.

From our earlier discussions, you may well have come to expect that, given

such a high symmetry, there must somehow be entailed a penalty owing to information denied. And there is indeed such a penalty: whether or not the energy state can be uniquely determined by the given quantum numbers depends on the shape of the box, its symmetry.

And how do you remove the symmetry degeneracy, the absence of a full description of the electron in the box owing to its symmetry? If you change the cubical box to one having only two of the axes the same, then some of the degeneracy disappears. If all three axes are made different lengths, the former symmetry degeneracy is removed.[11]

Removal of the information-withholding symmetry, the breaking of the symmetry of the enclosing box, allows the quantum mechanical properties of the electron to be fully specified, again reflecting the theme of symmetry breaking and information.

# 4  The Balance of Shapes

Symmetry breaking and the associated release of information are implicit in all of the arts as well. It should be no secret that many physicists find that the yin-yang balance in their lives requires sharing of their scientific world with the arts. The important role of form in music and literature,[1] as well as in the visual arts, has no small role in this attraction. Let us turn now to a few illustrations of how visual art is shaped by form.

## FORM AND *WHISTLER'S MOTHER*

Form assumes a basic compositional role in art, as it does in physics, guided by principles that include what one may call broken symmetry, rebalance, and unity. That many viewers have been too little aware of the implicit role of form in their appreciation of art was recognized by the painter James A. McNeill Whistler (1834–1903). He cited the misunderstanding of his full purposes in the painting of his mother, which now hangs in the Louvre. Although this perhaps overly familiar picture is popularly known as *Whistler's Mother,* his preferred title was *Arrangement in Gray and Black.*

　　In late nineteenth-century England, Whistler was criticized for a practice, now commonplace, that he helped pioneer: giving his paintings names that emphasized their formal properties rather than their storytelling ones. Let us hear Whistler's comments: "The vast majority of English folk cannot and will not consider a picture as a picture, apart from any story which it may be supposed to tell . . . As music is the poetry of sound, so is painting the poetry of sight . . . Take the picture of my mother, exhibited at the Royal Academy as an *Arrangement in Gray and Black.* Now that is what it is." The art historian John Canaday has commented in a similar vein on the Whistler painting.[2]

In his struggle to affirm his artistic positions and his pioneering style, in 1877 Whistler sued the art historian and critic John Ruskin for alleged libelous comments on some of Whistler's work. Whistler won but was awarded only one farthing. Echoes of such controversies remain with us.

## THE THREE-DIMENSIONAL SEESAW

Modern abstract sculptures offer clear examples of the artistic power of formal artistic elements. Consider a particular artistic device making use of symmetry and deviations from symmetry, which I shall call the three-dimensional seesaw. We are familiar with the seesaw, the children's playground device using a balance of torques, weights at the ends of balance arms. In the artist's application of the torque idea, different elements are placed in dialogue with each other, with the purpose of creating a balance of "artistic weight" not just in a plane but often in three dimensions.

Let us look at a sculpture by David Smith, called *Cubi X,* and one by Charles Ginnever, which he named *Roshamon.* These artworks offer transparently recognizable examples of what we shall call the balance of forms (shapes). So we shall start with these artworks despite their apparently abstract austerity.

David Smith (1906–65), one of the most important American sculptors of the first half of the twentieth century, worked in his later years on massive, welded-steel abstract forms, among which are his Cubi sculptures. When viewing these works, it is useful to think in very rough analogy with the seesaw, where the lighter person is placed farther from the center of the board so that balance of *artistic weight* is maintained.

The arrangement of rectangular parallelepiped shapes in *Cubi X* (figure 11) generates artistic tension and relief. It is a carefully planned array of rectangular forms, arranged in a delicate balance of artistic weights. As for the seesaw, larger shapes are set closer to an imaginary central axis than are smaller ones. If you were to walk around the sculpture, you would find persistence of the same unbalance-rebalance theme. Some of the forms are placed closer to the observer, while others are farther away. The same holds for the larger rectangles. Viewers walking around the sculpture find that, from almost any direction, not just edge-on, all of the constituent shapes participate in an intricate dance of unbalancing and rebalancing of artistic weight. An artist

Figure 11. David Smith, 1906–65,
*Cubi X,* 1963, stainless steel, 10 ft. 1⅜ in.
× 6 ft. 6¾ in. × 24 in. (© VAGA, NY.
Robert O. Lord Fund, 717.1968,
The Museum of Modern Art, New York,
NY. Digital image © The Museum of
Modern Art, licensed by Scala / Art
Resource, NY)

viewing the sculpture might summarize that it works in virtually every direction! We shall return to the meaning for artists of the judgment that a painting or sculpture "works."

Although the sculpture is large, the delicate balance of artistic weight projects a sense of lightness and motion. The unlikely "ballerina" displays precisely the disposition of "limbs" and "torso" needed to project the image of kinesthetic control. There is a clear weight-balance dialogue among all the parts of the work, satisfying the expectations of artistic reason.

In contrast to Smith's Cubi sculptures, where the balance of forms primarily involves horizontals and verticals, the Roshamon series by the distinguished contemporary sculptor Charles Ginnever captures an interplay of diagonals. Figure 12 shows one of Ginnever's abstract variations from that series.[3] As with the sculpture by Smith, there is no attempt at representation of "real" objects. For both Ginnever and Smith, however, the works satisfy some of the demands one unconsciously makes when looking even at natural shapes: They have to make sense in ways not unlike our expectations of a familiar image, such as that of a tree. Such examples remind us that a work of art, whether the subject is realistic or nonrepresentational, may be capable of offering a feast to our *seeing* eye.

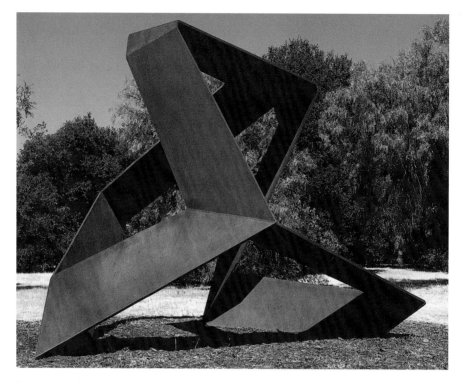

Figure 12. Charles Ginnever, *Roshamon,* steel, 13 ft. (Reproduced with permission of the artist, photo by Lee Fatheree)

An artist reviewing the Ginnever sculpture would immediately recognize that it works in every direction; in any pose, artistic weight is balanced. But, just as for the Smith sculpture, this balance is not achieved by automatically predictable action and reaction responses. An imbalance introduced in one place is answered in new terms, rather than simply by means of a strictly mirror symmetry.

Notice that the opposing diagonals in the foreground engage not only with each other but also with those in relative shadow behind. All lines are locked in contest in such a way as to generate a complementary chemistry. As viewers walk around the Ginnever sculpture, they find, when standing at any of a number of points, a balanced dialogue among contending voices.

What is remarkable and what truly earns for the sculpture the title *Roshamon* is the discovery that the *same* work retains intriguing qualities of artistic dialogue when it is rotated and flipped so as to stand in a number of different positions (figure 13). In each configuration the three-dimensional form

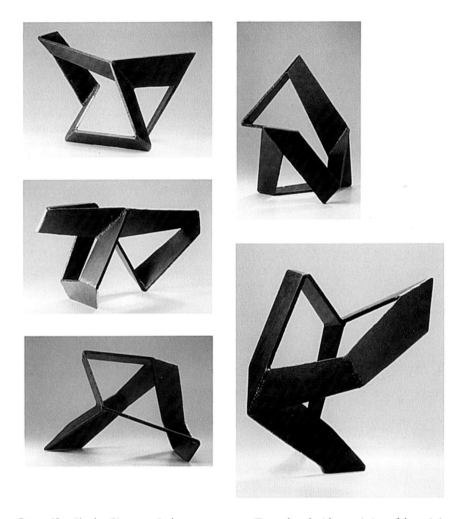

Figure 13. Charles Ginnever, *Roshamon* maquettes. (Reproduced with permission of the artist)

works: the sculpture maintains its intricate artistic equipoise from many viewing directions.

About a half-century ago the great Japanese filmmaker Akira Kurasawa made a film, *Roshamon,* in which different witnesses to a crime offer different stories about what had transpired. The lesson provided in the film is similar to the one Ginnever shares with his viewer: distinct perceptions of the same reality may be registered by different viewers—and by the same viewer when perspective is altered.

The general strategy of redressing unbalanced artistic weight appears quite

commonly not only in sculpture but also in painting. In a seascape, for example, the artist may choose to paint a sailboat just to the left of center and a smaller object, such as a bell buoy, farther to the right and, perhaps, a bit closer to the horizon as well. Extending the distance of the smaller object by moving it farther to the right and closer to the horizon increases its artistic weight by increasing the length of the arm of the seesaw. This allows the smaller object to redress the weight of the sailboat on the other side, in compliance with the seesaw strategy.

The examples cited thus far illustrate a common artistic strategy, a balance of shapes. This device is ubiquitous in visual art, whether sculpture or painting. But the strategies for creating this tension and redress can involve any in the entire range of artistic variables and not merely shape jousting with shape, as in the sculptures *Cubi X* and *Roshamon.* For example, in the hypothetical seascape just mentioned, suppose the artist decides that the bell buoy is not sufficient to rebalance the sailboat at the center left. He could choose to add other shapes elsewhere or, instead, reach into the bag of tricks for altogether different tools of art. We shall discuss some of these shortly.

One may well ask, Why not sidestep the entire game of rebalancing by placing the object of particular interest in the center? Often the purpose of not doing so, as in literature and music, is to allow for the generation and relief of artistic tension. A dull stasis is avoided and an engaging artistic dialogue is invited when the primary focus of attention is allowed to joust with competing artistic elements. The artistic debate and resolution give life to the work, contributing to the richness of expression and avoiding a static and stultifying compositional chemistry.

Generally, artists do not choose to attain unity by the seemingly most direct and expedient means. They invoke several design principles, which have been expressed in various essentially equivalent ways. In Edgar A. Whitney's terms, these are unity, conflict, dominance, repetition, alternation, balance, harmony, and gradation. To implement these principles artists invoke the elements of design: line, value, color, texture, shape, size, and direction.[4] Innumerable strategies other than weight balance, which was examined in isolation in the Smith and Ginnever sculptures, contribute toward compositional unity.

## BALANCE BY OTHER MEANS

To see a few other strategies for achieving compositional balance, let us move now to a new time, place, and art genre. Consider *Boating* (1874), a painting by Edouard Manet (figure 14). Here is a study in the balance of diagonals. The mast, boat, and figure of the woman are diagonal forms leaning to the left. Compositional dominance is represented by a single form, that of the man, leaning in the opposite direction. Notice that his arms, legs, and upper torso all align along diagonals. Manet's power to redress the influence of the other forms is greatly enhanced by his choice of the relatively high tint of the man's clothing, the larger mass, and the nearly central—but notice, not exactly central—placement of the figure. A central placement of the man would generate too static a composition. The same strategy dictates avoiding perfectly horizontal or vertical lines. Some of the other artistic variables used in this painting will be revisited when we discuss Impressionism.

In *Early Sunday Morning,* the American realist painter Edward Hopper (1882–1967) captures a mood many of us have felt (plate 2). One can almost

Figure 14. Edouard Manet, 1832–83, *Boating,* 1874, oil on canvas, 38 × 51 in. (Getty Images, The Bridgeman Art Library)

Plate 2.  Edward Hopper, 1882–1967, *Early Sunday Morning,* 1930, oil on canvas, 35 × 60 in. (Corbis.
© Francis G. Mayer)

hear the sound of heels echoing in the empty street. The scene recaptures my
memory of an early Sunday morning in Columbus, Ohio. My plane, which
had been scheduled to land in Chicago, was diverted owing to bad weather,
and I found myself searching for an open coffee shop early the next morning,
in such a setting as that captured by Hopper.

In the painting, the sense of isolation and foreboding is accentuated by the
orchestration of the scene and the absence of any sign of human activity. The
building, stretching across the entire canvas, is punctuated by a regular array
of windows and storefronts. In the long line of windows, there are no two in
which the shades and curtains are set in the same way. Here, the artist, like a
musical composer, is conscious of the need to create a variation on a theme.

Notice the very long shadows, consistent with early morning. Hopper
introduces variation in the array of colors and shapes of the storefronts to fur-
ther the breaking of symmetry. To balance the strong horizontal lines, includ-
ing those of the sidewalk, Hopper paints the barber pole and the shapes of
the windows and doorways as long rectangles. The colorful attraction of the
barber pole suggests to Hopper that he should make sure not to place it at
dead center to avoid a too static arrangement of forms.

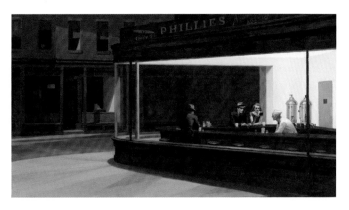

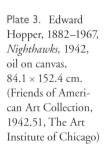

Plate 3. Edward Hopper, 1882–1967, *Nighthawks*, 1942, oil on canvas, 84.1 × 152.4 cm. (Friends of American Art Collection, 1942.51, The Art Institute of Chicago)

Hopper's own deeply introspective and retiring personality was often expressed in his artistic themes. This was evident in some of his cityscapes, which are frequently devoid of life, as in plate 2. Even when several people are depicted, they seem lost in private reverie, unconscious of each other's presence.

Perhaps his most famous painting, *Nighthawks* (plate 3), illustrates this quality. Four silent and seemingly frozen figures, oblivious to each other, stare straight ahead. The interior light leaks eerily from the large glass window into the forbidding surrounds. The composition serves as an ingenious vehicle for the mood of the painting. The shape of the café juts into the darkness, abiding by a principle of art composition emphasized by Edgar Whitney: dramatic shape should be wider than tall and should be asymmetrical as it intrudes into the painting. (Of course, principles of art are often best observed in the breach.) An excellent source on Hopper paintings is the book by the art historian Gail Levin.[5]

Edward Hopper's wife Jo, in attempting to describe his personality, said that he was like a deep well. When you cast a stone in the well, you wait for the sound of the splash, but none returns.

## FORMAL BALANCE AND THE IDEALIZED FIGURE

Unbalanced and rebalanced arrangements of forms can generate desired artistic tension and resolution. But sometimes a seemingly static formula is followed intentionally, as when the purpose is to emphasize the importance of a centrally placed figure or icon. A virtual mirror symmetry is used; the images on both sides of the center are often chosen to be similar in artistic weight. This compositional type is called formal balance, or bilateral symmetry.

Plate 4. Michelangelo, 1475–1564, *The Tomb of Giuliano de' Medici,* 1526–33 (after cleaning), Medici Chapels (New Sacristy), S. Lorenzo, Florence, Italy. (Photo by Scala / Art Resource, NY)

One of the great giants of Italian Renaissance art, Michelangelo (Michelangelo Buonarroti, 1475–1564),[6] used this compositional device in strikingly powerful fashion, as one can readily see in his sculptures for the tomb of Giuliano de' Medici, Duke of Nemours (plate 4). Given the purpose of the work, the glorification of the duke, Michelangelo naturally deemed the formal balance arrangement to be appropriate. So he arranged the sculpted figure of the duke to be at the center and above the other figures, which are placed symmetrically about Giuliano.

Despite the constraints inherent in the commission he was assigned, Michelangelo managed to fold in a high degree of artistic tension. Notice the break and rebalance of symmetry in the duke's pose. His right arm and knee are shifted to his right, while his head is turned in the other direction. In rendering the forms of the two surrounding allegorical figures, Night and Day, Michelangelo characteristically imbued them with vitality and motion. Although they serve their intended role as foils, emphasizing the centrality of the duke, Michelangelo did not miss the opportunity to generate artistic tension here as well, using compensating deviations from symmetry. In each of those side figures, the torso is twisted so that the upper and lower portions of the body turn oppositely. When comparing them, you discover that their respective twists are oppositely directed relative to each other. Although one is not expected to do a conscious "symmetry calculus" in viewing the sculptures, Michelangelo's subtle injections of these artistic devices enhances the artistic power of the magnificently rendered figures.

A compositional strategy using formal balance that appears in examples of sculpture as well as painting involves a pyramidal arrangement, as in the moving Vietnam Women's Memorial sculpture by Glenna Goodacre. The sculpture stands on a grassy knoll near the Vietnam Veterans Memorial in Washington, D.C. On each side of the pyramid is a powerful and wrenchingly emotional testament to the tragedy of war. While the context, the tragic history evoked by the sculpture, is sufficient to draw our interest as viewers, the work owes much of its poignancy and power to the form and overall design, which captures a pieta in a three-sided pyramidal shape. Here again is a theme that invites the formal-balance design. The solemnity of subject demands our full and focused attention, which the artist captures by invoking the symmetrical arrangement.

# 5  Some Visual Elements in Art

Just as only a small number of physical laws underlie some of the unimaginably diverse phenomena in our physical world, so do only a few basic design principles and elements of art yield the virtually limitless means of artistic expression. In art, the information vacuum symbolized by our fish in a boundless and featureless sea may be likened to the virginal two- or three-dimensional spaces for painting and sculpture. An artist starts with the blank canvas as the ground of symmetry, and, informed by his aesthetic sensibilities, he arranges artistic elements to create an artistic dialogue that expresses coherence. The special response elicited by artistic expression requires recognizably related deviations from the initial symmetry of the unmarked canvas, crafted so as to recover an aesthetic balance among all of the conversing elements.

## A FEW HIGH POINTS OF DESIGN

The artist seeks a balanced compositional statement, using the principles and elements of design. Guided by principles of design, the elements are played off against each other in the orchestration of a coherent composition. The modes of artistic expression are virtually limitless. No compressed summary can even begin to capture the creative inventions realizable in the eye and hand of the artist.

The Minimalist art of the 1960s to early 1970s showed how a very limited range of artistic elements can create beautifully appealing works. Subtle and ingenious examples are the paintings *Blue Monochrome* (1961) by Yves Klein and *Grove Group, I* (1973) by Brice Marden. In the work by Yves Klein, a deep, electric blue covers the entire surface. In Marden's painting, the medium

is oil and wax; a subtle interpenetration of blue-greens and green-blues fills the space. The paintings are not shown here because the subtle effects of surface and hue, clearly visible in the originals, do not reveal themselves adequately in reproductions.

Established ground rules are regularly broken and new trails are blazed. While not worn as straitjackets by artists, central tenets are evident in many examples of important art. Unity is one of the principles of design mentioned in the last chapter. *Unity* expresses the need for the composition to display integration, to show itself to be a self-contained "organism," an internally consistent whole. According to Whitney, "Just as one bar of *St. Louis Blues* played in the middle of *Ave Maria* would destroy the unity of the musical composition, . . . so any extraneous [element] not repeated, echoed, integrated elsewhere, would compromise unity."[1]

Of course, unity is guaranteed in the blank canvas. But then the composition is devoid of rich artistic statement; it contains little information and has too much symmetry. It falls to the remaining principles of design to provide strategies for artistic statements to be made without destroying unity in the process. So, along with the artistic tension, conflict, and contrast, there must be included the temporizing forces needed to preserve coherence and unity. An obvious proviso: many rules, seemingly appropriate to a given creative period or movement, can show themselves to be a less than perfect fit under a new set of perspectives.

A complex mix of artistic elements is represented under a single label, color, which may be said to have three "dimensions," or aspects.

- *Hue.* The name of a color—red, dark red, orange-red, blue, green, yellow, and so on.
- *Value, or tonal value.* The lightness or darkness of a color having the same or a different hue. Adding a lighter color or white (tinting) increases the value of a given color; adding a darker color or black (shading) decreases its value. As white is increasingly added to black, we say that the value of the mix has been heightened, or increased. The crucial role generally played by tonal value, or value, in establishing effective composition cannot be overemphasized.
- *Intensity (or chroma, saturation, brilliance).* The sense of brightness or dullness of a color. "Natural", or "pure," yellow (i.e., yellow not mixed with

other hues) appears to be brighter than pure red or blue. So we say it has higher intensity, or saturation. In some cases adding small amounts of other hues can significantly increase or decrease the intensity.

These three color-dimensions may, to some extent, be manipulated independently. For example, adding white to red changes the level of saturation without changing the hue. Many artists would add *warm* versus *cold,* elements that we will discuss shortly, as additional color variables belonging to the aforementioned list of color properties.

In reviewing rudimentary ideas about color complements and treating some other aspects of the subject of color, it is helpful to refer briefly to a somewhat simplistic but useful representation, shown in figure 15. The primary colors for pigments, as opposed to colors obtained by mixing different wavelengths of light, are generally taken to be red (R in the diagram), blue (B), and yellow (Y). They are called primaries because the other hues can be made from them. Color theorists will argue that it is simplistic to reduce the description of actually available pigments in this way. But, for simplicity, we shall use the terminology.

The secondary colors are situated between the primaries on the wheel. They are called secondaries because they can be mixed from their neighboring primaries: green (G) from Y and B, violet (V) from B and R, and orange (O) from R and Y. The intermediate colors, such as blue-violet, red-violet, and yellow-orange, have not been labeled in figure 15. Certainly, there is a continuous spectrum of possible pigment mixtures. The possible varia-

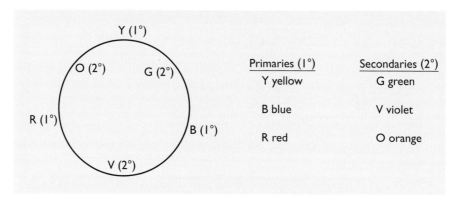

Figure 15. A basic color wheel for pigments

tions of hue, value, and intensity are virtually limitless. The analogous colors are those nearest each other on the wheel. As the relative positions suggest, the analogous colors are the most closely related, and when placed near one another or used as mixed pigments, they generally produce harmonious effects.

Finally, the complementary, or contrasting, colors are opposite or nearly opposite each other on the color wheel. Since the complement of yellow is violet, the complement of yellow can be made from a mix of the other two primaries, which together make violet. Placing complements adjacent to each other in a composition can produce dramatic color effects. For example, in some of Claude Monet's paintings he has set poppies in a field of their muted green complement in order to enhance the red of the poppies.

Paint colors are referred to as *subtractive,* since mixing tends to darken them. Mixing the primaries darkens the mix. In contrast, the process of mixing differently colored lights is called *additive,* since the result is lighter. There, the primaries are generally taken to be blue or blue-violet, green, and red, with the equal mixture of all three giving white.

This was demonstrated by Isaac Newton in his famous experiment with a glass prism about three hundred years ago. Placing a small hole in a curtain in a darkened room, Newton directed a beam of white light onto a glass prism, from which the beam emerged as a rainbow spectrum of colors. When passed downstream into a second, now inverted prism, the spectrum of colors recombined into a beam of white light.

The aesthetic effect of different colors depends in subtle ways on the setting in which those pigments are placed and on the manner in which they are applied. Artists face a daunting task in recognizing how the appearance of colors is subtly affected by the choice of their relative transparencies, adjacent colors, pigment medium, surface texture, brush technique, underlying hues, and thickness of paint applied. While analogous colors generate harmony, adjacently placed complements often serve as antagonists or add accent to the stew. Sometimes a clash is sought, but when it is subtle accent and not chili pepper that is wanted, the effect can be tempered by using relatively small adjacent areas or a muted intensity of the complement—again, as in the Monet poppy fields. At the same time, complements of the same value can often be placed contiguously to produce beautifully orchestrated effects.

An example of the intentional use of adjacent complements to produce a

dissonant note is recorded in a letter written by Vincent Van Gogh to his brother Theo, regarding Vincent's plans for his painting *The Night Café* (1888).

> To Theo, Arles, 8 September 1888: . . . I have tried to express the terrible passions of humanity by means of red and green. The room is blood red and dark yellow with a green billiard table in the middle; there are four citron-yellow lamps with a glow of orange and green. Everywhere there is a clash and contrast of the most disparate reds and greens in the figures of little sleeping hooligans, in the empty, dreary room in violet and blue. The blood-red and the yellow-green of the billiard table, for instance, [contrast with other objects in the room].

In another letter written to Theo at about the same time and regarding the same painting, the artist added the following: "In my picture of *The Night Café* I have tried to express the idea that the café is a place where one can ruin oneself, go mad, or commit a crime. So I have tried to express, as it were, the powers of darkness in a low public house."[2]

As already indicated, mixing a pigment hue with some of its complement may have the effect of dulling, or graying, the color. Complements of similar value can often be combined or placed adjacent to each other in such a manner as to create beautiful effects. As already suggested, a neutral gray can be made from a roughly equal mix of pigments related to the three primary colors, while the warm and cool grays may be derived from unequal mixes of the primaries.

Generally, the colors near a red pigment are labeled warm, while those near blue are cool, but each hue can be found in versions judged relatively warmer or cooler. The artist can get a host of subtle variations by mixing pairs of pigment complements—yellow and violet, blue and orange, or red and green—in various relative concentrations.

In particular circumstances, applying warm or cool colors in painting may cause objects to appear to pull toward or push away from the viewer. Anyone who has noticed the bluing of hills as they recede from view will recognize the effect. The "push-pull" effects of colors defy simple characterization. There are, for example, blues that are warmer than some reds.

While there are well-defined criteria for testing a scientific theory, such as consistency with known physical facts and falsifiability,[3] art, too, is subject to testing, albeit of a quite different sort. The artist asks himself, Does it "work"?

And the same question then becomes the preoccupation of scholars and the viewing public.[4]

In attempting to create a painting that "works," the artist wrestles with a host of artistic elements. These include color and shape, texture and brush, shade and tint—all assembled to promote balance, tension, and, ultimately, an organic unity. According to Ernst Gombrich: "[The artist] has, on his canvas, perhaps hundreds of shades and forms that he must balance . . . Once he has succeeded, we all feel that he has achieved something to which nothing could be added, something that is right—an example of perfection in our very imperfect world."[5]

An e-mail I received recently from an accomplished watercolor painter offers a small insight into the arduous path taken by artists in their work. He was ecstatic over having found a transparent red that was compatible with the transparent blue and yellow in his palette. He observed that, among the nonfugitive (not fading in sunlight) transparent reds, "all the others were toward the orange rather than toward the violet end of the spectrum. Orange, of course, includes yellow, and since yellow is the complement of violet, when these reds are mixed with blue, they yield a dull violet. [The new red is in balance with the other transparent primaries] i.e., mixing together equal amounts of each yields a middle gray, which can be adjusted toward any of the three hues by varying the mixture . . . Could life be any better?"[6]

I recall witnessing a scene in an art studio that provides another small example of the arduous path artists follow in their work. A talented student working toward her MFA (master of fine arts) degree paused in puzzled concentration in front of her easel. Two instructors were standing by her side. Wordless, all were in deep thought in front of the student's painting. (A personal aside: An easily sustained conviction is that good artists are frequently brilliant people, but a few are very sparing with words, saving their deep thoughts for creative artistic expression. It is interesting to see this tendency revealed in actual practice.) The three stood there for some time before one of the instructors said, "Why don't you put something, like a chair, there." All understood without words what the problem was, and where "there" was. The implicit recognition of the problem of form in the painting was seen by all three. A possible means for its solution, wordlessly understood and shared, was very instructive to this observer.

## THE RHYTHM OF FORM, TONE, AND LINE

In chapter 4 we discussed examples of the balance of forms (shapes) in the sculptures of David Smith and Charles Ginnever. In this section and a few to follow, let us look at art that makes use of what I shall call the rhythm of forms, tone, and line. One might try to show each of these characteristics separately in different paintings, but they seldom occur in isolation.

It is tempting to see, in the contrast between balance and rhythm in art, a metaphorical parallel with static and dynamic equilibrium in physics. A balance of forces can result either in no motion (static equilibrium) or in a smoothly moving system, that is, one moving but with unchanging velocity (dynamic equilibrium). Further, there is an acceleration of motion when the forces are unbalanced. This, too, often has a parallel in art.

Artistic devices based in shape, tone, and line stimulate the eye's energetic movement along a path set by the artist. The work of art is clearly fixed in place, bounded and restrained by the frame, but its elements engage in a subtle dance. The possible examples in the vast ocean of artworks are virtually infinite, but a few instances will serve as illustrations.

The painting *Grazing Horses, 4,* also known as *Red Horses* (1911), by Franz Marc (1880–1916), is a symphony of movement, enlisting as actors red horses, hills, blue boulders, and rocks (plate 5). The muted adjacent colors highlight the red horses, which represent an exquisite arrangement of related kinetic forms. Note that the artist arranges the shape and pose of each horse in a rhythmic balance with the others. The stylized arrangement of interconnected hooves, manes, and overall shapes projects a gentle vitality. Those gracefully interlocking curves are echoed in the gently rolling hills. The sum of these contesting forces creates an appealing artistic coherence.

Incidentally, Marc, who was killed at Verdun in 1916 during the First World War, was a prominent member of a group of artists called the Blue Riders *(Blaue Reiter),* or Blue Horsemen. Blue Riders was the identifying label for a group of German Expressionist painters somewhat similar in their artistic objectives to the Wild Beasts *(Les Fauves)* in France. Among the latter was Henri Matisse, a prominent contemporary of Picasso, whose work we shall see shortly.

Among the characteristics of Expressionism is the use of unnatural color to serve as a vehicle for emotional statement. In the present example, the unnat-

Plate 5. Franz Marc, 1880–1916, *Grazing Horses, 4,* 1911, oil, 47.6 × 72 in. (Hermann Buresch, private collection. Photo by Bildarchiv, Preussischer Kulturbesitz / Art Resource, NY)

ural background hues—such as the muted, complementary color green—serve to suppress the supporting stage set and emphasize the central, foreground forms of red horses.

Under the category of *rhythm of forms,* an intriguing further example might be the use of color itself to make forms appear to move forward (the warmer colors) or backward. Twentieth-century abstract painter Hans Hoffman uses the "push-pull" device to powerful effect when he places on his canvasses overlapping or adjacent blocks of different bold colors, warm and cold, appearing to jut forward or to recede. Our last example, *Red Horses,* demonstrates this effect in somewhat less dramatic fashion. The choice of a bold red, especially in contrast to the background colors, thrusts the horses to the foreground.

One of the paintings in Picasso's Blue Period (roughly, 1903–5), *The Old Guitarist,* shows the power of rhythm of forms and tone. In plate 6, you see a figure with head, hands, and arms folded about him in a stylized way frequently found in Picasso's works of this period. To enhance the sense of enclo-

Plate 6. Pablo Picasso, 1881–1973, *The Old Guitarist,* 1903–4, oil on panel, 122.9 × 82.6 cm. (Helen Birch Bartlett Memorial Collection, 1926.253, The Art Institute of Chicago)

sure, the lengths of arms, hands, and fingers are exaggerated in a Mannerist fashion reminiscent of El Greco.[7]

The painting illustrates the effectiveness of changes of tone (light and dark) in infusing movement in a seemingly static composition. Despite the restriction basically to blue-violet, Picasso uses a remarkably varied range of tonal values within an essentially monochromatic painting by devices such as adding white or removing red. While the guitar is of a different hue, it is of a grayer tone relative to its immediate surroundings, with the effect that it does not capture undue attention despite its central location.

For a further illustration, let us turn back a few centuries and view plate 7, *The Marriage of Giovanni Arnolfini and Giovanna Cenami* (1434), by Jan Van Eyck, one of the fifteenth-century pioneers in the development of oil painting techniques. Incidentally, the painting could also have been cited in chapter 4 to illustrate the mastery of hue. Despite the contiguous and large areas of the complements red and green, the hues in the bride's dress and its immediate background of tapestry and bedding are made harmonious by their sharing of yellow. Further, the addition of yellow in the gown enhances its intensity and

Plate 7. Jan Van Eyck, c. 1390–1441, *The Arnolfini Wedding*, 1434 (also known as *The Marriage of Giovanni Arnolfini and Giovanna Cenami*), oil. (National Gallery, London. Photo by Erich Lessing / Art Resource, NY)

draws attention to it. The neutral walls, floor, and attire of the groom stand in muted contrast.

The picture, painted in 1434, is regarded as a milestone in the use of new, or rediscovered, oil techniques. The point in making a paint is to suspend the pigment particles in a suitable medium, permitting acceptable drying time, color stability, brilliance, and workability on the brush. Artists have experimented with a host of media over the ages. At one time, Italian and Greek artists tried olive oil but found its very long drying time to be a great disadvantage. Egg tempera uses egg in its medium and is favored by some artists even today. But some object to its muting of hues. Varnishes are often added to shorten the drying time of some media.

Giorgio Vasari, whom we met in connection with the discussion of Michelangelo, wrote in his *Lives of the Artists* that basic, modern oil-painting techniques were discovered—or rediscovered—by Van Eyck. He is credited with using currently favored oils like linseed, as well as effective varnishes for drying and preserving surfaces. The oil in which the pigment particles are suspended has the effect, owing to what physicists refer to as the index of refraction, of causing light rays to penetrate the paint layer, or layers, and re-emerge. The result is a greater luminosity of the paint. The effect is enhanced when several successive thin layers are used. A prepared white, or very light, ground enhances the reflectivity of the painting.

The Van Eyck painting documents marriage vows witnessed by the signature of the artist himself on the back wall in the painting. So it is reasonable that the picture should contain traditional household symbols appropriate to custom at the time and place of the Arnolfini wedding, such as the household pet and the slippers.[8] But the placement of those objects has an interesting formal artistic role, as well, in supporting the rhythm of tone. Notice in the accompanying black-and-white version (figure 16) that a path of light and dark becomes more evident than in the color plate. The eye is led through the painting via a path of light. The trail winds across the midportion to the joined hands. From there it traces to the highlights in the bride's veil, down through the edging around her gown, across the lower portion of the painting aided by the heightened tone of the poodle's back, then to the slippers strategically placed at the lower left, and finally to the brightly lighted window.

While, as Canaday observes, the inclusion of such domestic symbols as the poodle and slippers is appropriate to the subject of the painting, we can

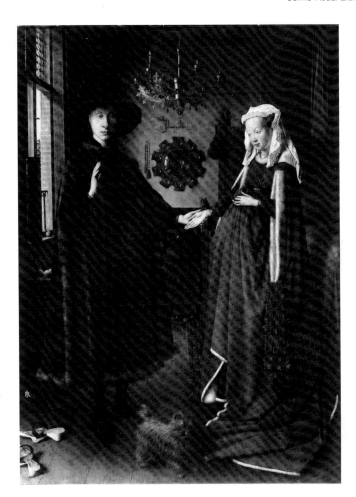

Figure 16. Jan Van
Eyck, c. 1390–1441,
*The Arnolfini
Wedding,* 1434.
(National Gallery,
London. Photo
by Alinari / Art
Resource, NY)

now understand why Van Eyck chooses to place them where he does in order
to provide guidance for the eye's path through the artwork. The dance of light
brings elements of vitality into the composition, which you may say it sorely
needs, given the wooden postures of the figures, accentuated by the lugubri-
ous facial expression of the groom.

The bride is made the dominant figure, owing to use of more intense
hues in the gown and immediate surroundings. But the artist, in observing
the design principle of dominance and suppression, does not allow the estab-
lished focal area surrounding the bride to unbalance the composition. The
enhanced color intensity of the right side of the painting, as compared with

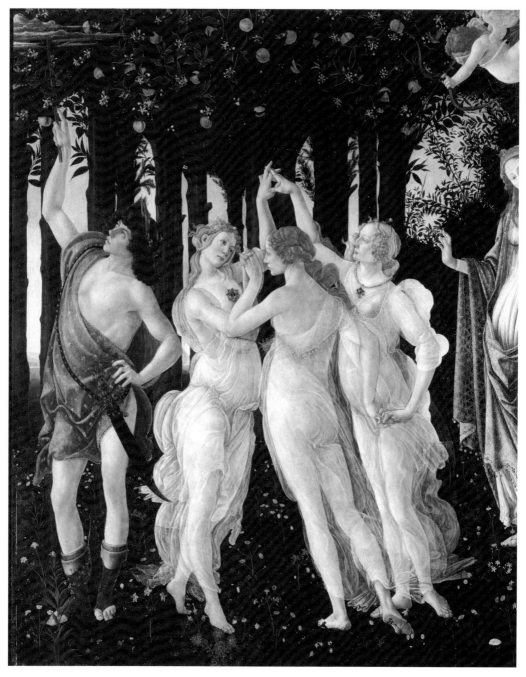

Plate 8. Sandro Botticelli, 1444–1510, detail from *La Primavera, the Three Graces,* 1482. (Uffizi, Florence, Italy. Photo by Scala / Art Resource, NY)

the muted notes provided by the husband's apparel, is redressed by the strong light source at the left.

Returning to Picasso's *The Old Guitarist,* we notice, in a manner similar to that of the Van Eyck, that virtuosity in the arrangement of light leads the eye around the painting. Beautiful variations on the theme of grayed blue highlights play on legs, arms, head, neck, and the panel behind the head.

Evidence for the power of rhythm of line in composition can be seen in different art periods and in works based on distinct styles. First consider the 1482 Sandro Botticelli painting *Primavera,* a huge panel 6 feet 8 inches by 10 feet 4 inches. The work is best known for a detail within (plate 8), a group of three figures commonly known by a separate title, *The Three Graces.*

It is interesting that this detail is better known than the larger painting from which it derives. As a composition it is arguably far superior to the entire *Primavera;* the detail hangs together far more successfully than does its parent painting. *The Three Graces* is restricted in hue, a golden monochrome, which helps to unify the work. Here, in a single remarkable example, we see demonstrated three of the attributes already cited, rhythm of forms, line, and tonal value, as magnificently rendered compositional elements. Notice the additional devices contributing here to the creation of a coherent and fully integrated composition, such as the graceful linking of hands and the fluid arrangement of arms. This lyrical phrasing of shapes brings to mind the flow of forms in the Franz Marc painting (plate 5).

But it is the role of flowing, graceful line that is of paramount importance in making a powerful, unifying artistic statement in *The Three Graces.* While the next example represents an apparently drastic departure in time period and in art genre, the role of rhythm of line remains centrally important here, too. Consider plate 9, an example of so-called Action Painting: *Lavender Mist* by Jackson Pollock (1912–56). This nonrepresentational painting repays careful examination.

It is the emphasis on line as an artistic element that has brought us to this painting. But its abstract nature immediately begs the question among some viewers, Why should we care about such a picture? The question might not have come to mind if there had been present familiar shapes from nature. But this should not prevent us from examining here the power of pure form in feeding our seeing eye.

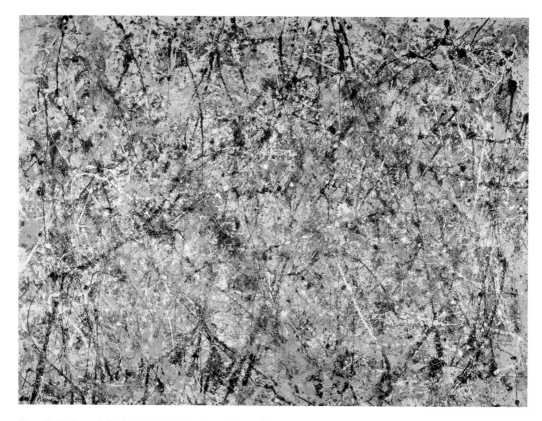

Plate 9. Jackson Pollock, 1912–56, *Number 1 (Lavender Mist),* 1950. (Alisa Mellon Bruce Fund. Image © 2007, Board of Trustees, National Gallery of Art, Washington, D.C.)

If *Lavender Mist* had been a faintly recognizable garden scene, like the late water lily paintings of Monet, some of those viewers who have trouble with it might find it less daunting. E. G. Landau points out that "the atmospheric effect of this painting has frequently elicited comparisons with the [late water lily subjects] of Claude Monet . . . [The painting] shows Pollock evoking nature's transcendent beauty, combining feeling and sense perception into a lyrical visual tonality."[9]

Of course, Pollock was not constrained by such a literal image. In the painting, a rhythm of interpenetrating lines, primarily of white and black, bind a gauze of lavender, accented with grayed green. The painting is an integrated, organic statement of surpassing beauty. *Lavender Mist* succeeds as a unified composition despite the absence of explicit clues to the existence of a "garden," revealing its aesthetic message slowly and seductively.

I urge all who visit Washington, D.C., to see it, in the East Building of the National Gallery of Art. Take a seat at the bench placed in front of this large painting, which occupies most of an entire wall devoted to its display, and lose yourself in its deep recesses. As is invariably the case, but especially with an example such as this, the reproduction cannot do justice to the original seen in its full scale and true colors.

# 6    Searching for Light

It is curious that, in both art and physics, the great diversity of expression depends on the manipulation of relatively few elements and principles of design. We have already seen some evidence of this in the few examples culled from artworks thus far.

In physics as well, we saw the overwhelming power of a few conservation laws and symmetries to govern the shape of physical law. Persuasive examples of such physical laws are Maxwell's theory of classical electromagnetism and Einstein's relativity theory. The term *classical* here refers to physics before the advent of quantum theory, which was born at the turn of the twentieth century and reached a level of maturity in the next thirty years or so.

Basic building blocks of understanding of electromagnetism grew over centuries. The keystone was laid in the 1860s by James Clerk Maxwell. His great contribution depended on an important conservation idea, the conservation of electrical charge, as we shall see. The present chapter briefly outlines the discovery path of classical electromagnetism to illustrate the construction of a fully realized composition from elements gathered over centuries and completed by applying that symmetry idea.

One can well imagine the painter's or sculptor's "agony and ecstasy" in directing the brush or chisel so as to create a great work of art, a coherent and eloquent expression of the intended aesthetic plan.[1] In retrospect, one can clearly see the analogous growth in our understanding of electrical and magnetic fields and their interaction with matter. In the nineteenth century, successive building blocks were set by scientists such as Hans Christian Oersted, André Marie Ampère, Jean Baptiste Biot, Françoise Savart, Joseph Henry, and Michael Faraday.

As we shall see, it was Maxwell who provided the missing puzzle piece— remarkably, with the aid of an incorrect mechanical model for the medium

supposed at that time to pervade space. The classical picture, a masterpiece of internal coherence and implication, was now complete. And it was greater than might have been predicted from scrutiny of its separate parts.

Maxwell's discovery, which we shall examine shortly, culminated in the theoretical discovery of electromagnetic waves and the identification of light as an electromagnetic wave. But implicit in the equation for electromagnetic waves was a threat of relativism that had not appeared in Newton's laws of mechanics. As you will see in the next chapter, Einstein felt that it was unacceptable for relativism to intrude in any law of physics, that natural law should not depend on who was doing the observing. Again, the preservation of a fundamental symmetry was at stake. Happily, new implications brushed in by Einstein in 1905 removed that threat. The special theory of relativity broadened our horizon, giving rise to a new understanding of space and time. These are the stories of the present chapter and part of the next.

## THE FIRST STEPS WITH LODESTONE AND AMBER

Let us begin by revisiting commonly experienced phenomena: the mysterious push and pull between magnets, the spark that often appears at the touch of a doorknob, lightning in a thunderstorm, and hair standing on end when it is combed or brushed. The ancient Greeks were fascinated with such behavior, as demonstrated in the properties of lodestone and rubbed amber, which we now recognize as simple magnetic and electrical effects. The Greeks found that these strange materials could exert influences at a distance: the lodestone (the natural mineral magnetite, an oxide of iron) can attract or repel bits of ferrous metals, and the rubbed amber, solidified pitch from trees, can attract small objects. How is it that these lumps of matter can exert their pushes and pulls on each other without touching, that is, at a distance? Of course, the same question may be asked about gravitation: how does the earth exert its pull on the apple falling from the tree—and, by exactly the same rules, on the moon in its orbit—without "touching" them?

Isaac Newton was confronted with that question when he offered the mathematical law describing how the force of gravity behaves between spatially separated objects. The puzzle became known as the "action-at-a-distance" problem. Newton's response was, "I offer no hypotheses." In other words, he felt

it sufficient at that time to offer a formula (i.e., a mathematical prescription) describing in detail how the force of gravity depends on the masses and separation of objects from each other, whether they be the effect of the earth on an apple or its influence on the moon. Einstein's general theory of relativity, which we meet briefly at the end of chapter 7, provides a more satisfactory response to the question.

The action-at-a-distance mystery is more pervasive than one may at first realize. The influence of one object on another captivates us when their separations are readily perceptible—as for the pull or push of magnets or electrically charged objects or the attraction of gravity. But from the modern perspective, objects are never to be viewed as really pushing or pulling from "direct contact" with each other. It is a *field* that occupies the space between, and separates, atoms and molecules.

Classically described, a field characterizes a region of space that has been affected by the "source" of that field. A mass, for example, is associated with a field of influence around it in such a manner that another mass placed at some point in that field responds to the strength and direction of the gravitational field *at that point,* rather than, somehow, being influenced *remotely* by the other mass. Such a picture addresses the action-at-a-distance problem confronting Newton.

It was Michael Faraday (1791–1867) who introduced the notion of a field of force for electric and magnetic fields. He imagined "lines of force" extending in space from those sources. Anyone who has seen the school experiment showing the alignment of iron filings placed on a sheet of paper over a magnet can understand something of Faraday's vision. The nature of the fields related to all forces, not only those for electricity and magnetism, has been further clarified by developments in quantum physics, which continue to the present day.

One of the sources of electric field, which we shall designate by the symbol **E**, is associated with electric charge. Atoms consist of electrons, having negative electrical charge, surrounding a nucleus made up of neutrons with no electrical charge and positively charged protons, equal in number to the number of electrons in the electrically neutral atom. When electrons are removed from the atom, the positively charged nucleus and the freed negatively charged electron(s) each become sources of electric field in the surrounding space. This is the field you witness when your hair stands on end as

it is brushed, and it is the influence between clouds and the earth before light-ning strikes in a lightning storm.

Visitors to the archaeological treasures of Egypt may well be expected to be enthralled by the wonderful artifacts, relief sculptures, wall paintings, and accompanying hieroglyphs. Yet it wasn't until 1821, in a magnificent tour de force, that the French Egyptologist, Jean-François Champollion, building on the earlier work of Thomas Young (whom you met in chapter 3), was able to decipher some of the meaning of the hieroglyphs carved in relief on walls of those fabulous ruins. Armed with an idea of their meaning and significance, despite their inability personally to interpret them, visitors are prepared more fully to appreciate them.

It is in the same sense that we will now view some "icons" representing mathematical expressions of great symbolic power. Their significance can be appreciated without an understanding of the associated mathematics. While there is no intention to do math, the symbols are introduced primarily to represent succinctly the crucial historical stages in our understanding of elec-tromagnetism. Equally important, when observed together, they show pic-torially the interactions among elements making up coherent composition in a physical theory.

So let us see first the symbolic relationship in classical physics between stationary electrical charge and its field:

$$\nabla \cdot \mathbf{E} = \rho/\varepsilon_0.$$

At the level of classical physics, all that you may wish to know about the effect of electric charges at rest in empty space—the spatial configuration of their electric fields and the forces they exert on each other through their fields— is, remarkably, encapsulated in that tiny icon! The inverted triangle symbol (called *del*) and the associated dot represent, in mathematical shorthand, specific instructions on how the field $\mathbf{E}$ is distributed in space. The right-hand side of the equation represents the charge, the source of the electric field $\mathbf{E}$.

Magnets, too, have poles of two kinds, conventionally labeled not "posi-tive" and "negative," as for electric charge, but rather, as for the familiar com-pass needle, "north" and "south." Unlike the case for positive and negative electrical charges, north and south magnetic poles cannot be separated. North and south poles appear together; you cannot pull a magnet apart so as to get an isolated north or south pole. Thus, there is not a magnetic charge equiva-

lent to the electric charge. Such a charge is theoretically possible but has never been found.

A short mathematical statement expresses, with quantitative precision, that absence of isolated magnetic poles and the effect that this has on the magnetic field pattern:

$$\nabla \cdot \mathbf{B} = 0$$

It is all in that little icon! The symbol **B** stands for the magnetic field. The 0 on the right-hand side indicates the absence of magnetic charge.

## ONE FIELD DETERMINES THE OTHER

The two fields so elegantly represented by the icons introduced above seem, from what has been said, to stand in isolation; they appear, thus far, to be two separate pieces of independent information. To begin to appreciate that there is interplay between electricity and magnetism, let us return to Faraday. Michael Faraday was formally educated only through grade school but was introduced to books as a bookbinder's apprentice. While untrained in mathematics, he was an extraordinarily talented experimentalist and made most significant discoveries in chemistry and physics.

Faraday's intuition and experimental genius led to his discovery of electromagnetic induction, which represented a major step toward the full exposition of classical electromagnetism. He showed that a changing magnetic field produces an electric field! Remarkably, it is not necessary to have electrical charges in order to make an electric field, a connection shown in the first icon you saw above. This may also be accomplished by having a time-varying magnetic field (e.g., by changing the strength of a magnet or by moving the magnet toward or away from a given point). The discovery has found great application in the modern world, providing, for example, the basic mechanism for electrical power generation. To represent Faraday's idea, we now put forward another icon, again for symbolic purposes to be appreciated shortly. The precise prescription is

$$\nabla \times \mathbf{E} = -\frac{\partial \mathbf{B}}{\partial t}$$

The left side of the equation, incorporating the inverted triangle (del) fol-

lowed by the ×, is a shorthand mathematical instruction for the way that the electric field **E** is to be spatially distributed. The right side indicates the corresponding change in magnetic field **B** with progress of time $t$.

Certainly Faraday would not have expressed his discovery in such terms since he was not mathematically trained. He was guided in his work by his insightful physical intuition and experimental genius. Yet it is the precise mathematical formulation of the equations for classical electromagnetism that later enabled Maxwell to make a remarkable breakthrough in understanding. But first we must stop at one more waystation.

## MAXWELL'S GIANT STEP FORWARD

André Marie Ampère (1775–1836) and Hans Christian Oersted (1777–1851) found another piece of the puzzle. They found that a moving electric charge (i.e., an electrical current), which we shall identify by the label **J**, makes a magnetic field. In a common school experiment, this is demonstrated by taking a coil of wire, enclosing an iron nail to enhance the effect, connecting it to a battery, and discovering that a magnet—and its associated field, of course— has thereby been produced. The junkyard electromagnet, which easily lifts tons of ferrous metal, is simply a scaled-up version.

The formula for the effect is known as Ampere's law. When James Clerk Maxwell (1831–79) reexamined Ampere's law, he realized that it was incomplete, for it failed to account for the well-established fact that electric charge is conserved: Electrons do not vanish into and are not born out of thin air. Maxwell's extension of Ampere's equation, modified to take into account the conservation-of-charge requirement,[2] proved to be far more than a patch, for it placed the final block in the edifice of classical electromagnetism.

Notice again the guidance of conservation ideas, which, remember, are equivalent to particular symmetries. With Maxwell's contribution of the missing term, coherence and unification were attained in classical electromagnetism. The completed composition, the now internally consistent theory, had revolutionary implications.

Let us show this icon, the Ampere relation, as corrected by Maxwell:

$$\nabla \times \mathbf{B} = \mu_0 \mathbf{J} + \frac{1}{c^2} \frac{\partial \mathbf{E}}{\partial t}$$

The magnetic field **B**, on the left-hand side, has two sources, listed on the right-hand side: the current **J** (that is, moving electrical charge), which is the part introduced by Ampère to describe the fact that electrical current gives rise to magnetic field, and a new contribution at the far right. That second term on the right-hand side of the equation is the crucial additional contribution of Maxwell. Without that additional term, the requirement that charge be conserved is violated.[3]

Recall Faraday's discovery that a varying magnetic field creates an electric field. Reciprocity, much revered by Mother Nature, would suggest that the inverse must be true, that is, one of the relationships should require the other. The last equation says so. But the experimental confirmation of the predicted relationship proved difficult and was not accomplished until many years later.

## THE ICONS REVEAL LIGHT

Given Maxwell's correction term, the four icons (now called Maxwell's equations), taken together, represent an internally consistent whole. So we find it entirely appropriate to arrange them within the same picture frame, as shown in figure 17.

The inhibitory response many people feel in the presence of anything smacking of math would be inappropriate here, for the purpose of displaying the figure is hardly to calculate. But we should feel the poorer if we were denied the opportunity to see beautiful icons and calligraphy, especially if given a sense of their subliminal secrets. So let us persevere.

The Maxwell equations appear at the four corners of figure 17. It is important to realize that all phenomena within classical electromagnetism are described—every jot and tittle—by the Maxwell equations. This includes much that we take for granted in the functioning of modern society.

Figure 17 has its own compositional logic, not unlike that of the composition in a painting. What are the two equations in the middle all about? This is where mathematics shows its important distinction from traditional languages, even pictographic ones. The two equations in the middle of the picture are not independent of the others, although they certainly look different in form; we would all—mathematically literate or not—recognize these icons as having different form from the equations in the corners. Yet, math-

$$\nabla \cdot \mathbf{E} = \rho/\epsilon_0 \qquad\qquad\qquad\qquad \nabla \cdot \mathbf{B} = 0$$

$$\nabla^2 \mathbf{E} - \frac{1}{c^2}\frac{\partial^2 \mathbf{E}}{\partial t^2} = 0$$

$$\nabla^2 \mathbf{B} - \frac{1}{c^2}\frac{\partial^2 \mathbf{B}}{\partial t^2} = 0$$

$$\nabla \times \mathbf{E} = -\frac{\partial \mathbf{B}}{\partial t} \qquad\qquad\qquad \nabla \times \mathbf{B} = \mu_0 \mathbf{J} + \frac{1}{c^2}\frac{\partial \mathbf{E}}{\partial t}$$

Figure 17. Let there be light.

ematical manipulation of the Maxwell equations (the equations in the four corners) shows that the two new equations had been buried within![4]

What is remarkable about the two new equations is that they say electric fields, **E**, and magnetic fields, **B**, can propagate as waves through empty space, even with no intervening material substance! That light is associated with electric and magnetic fields had already been suggested,[5] but the work of Maxwell put the concept on firm footing analytically. Further, the actual numerical value of the wave velocity, symbolized by the $c$ in the equations in the middle of the picture, is readable from these equations and is found to be the same as the speed of light, which was already known from experimental observation. Light is an electromagnetic wave!

While visible light is an example of an electromagnetic wave, there are many other familiar examples of electromagnetic waves, such as microwaves (used in microwave ovens, radar, satellite reception), x-rays, radio waves, and ultraviolet and infrared waves. All of these waves differ only in their wavelengths, the distance between wave crests. The retinas of our eyes detect a narrow range of wavelengths, lying between about 400 and 700 nanometers. (A nanometer, a thousandth of a millionth of a meter, is the length of a few atoms laid end-to-end.) Our eyes are useless as detectors of electromagnetic waves having longer or shorter wavelengths.

We have seen seemingly independent pieces of information, represented by successive insights, lead to the Maxwell equations. These equations offer a powerful example of a beautifully integrated composition, constructed from seemingly independent strokes. The resulting composition speaks to far more than the apparent promise of the separate parts. The rich repository of infor-

mation and beauty represented within our framed painting (figure 17) is analogous, in art, to the interwoven conversational voices making up a powerful artistic composition, examples of which appeared in earlier chapters and will reappear as our exploration of physics and art continues.

## LIGHT AS AN ELECTROMAGNETIC WAVE

Electromagnetic waves, bearing the message of interrelated waves of electric and magnetic fields, are entirely unlike those one commonly encounters. Consider the familiar water wave, which moves toward shore and bends around obstacles such as boats and rock breakwaters. Such waves are disturbances of the water medium that propagate from one point to another. Similarly, a material medium is needed for sound waves in air: here, the wave is a propagating disturbance of the air. But this is not the case for light or other electromagnetic waves.

This distinction is dramatically demonstrated in a fairly familiar experiment. Air is removed from a container enclosing a ringing bell and a lighted electric bulb. As more and more air is withdrawn, the sound of the bell becomes ever fainter until it disappears completely. But the light is not dimmed.

In Maxwell's time the idea that any kind of wave must have a material medium in which to propagate was firmly implanted. But what is that material medium supporting the light wave? For that matter, what supports the light waves from distant stars in their travels to our eyes through space, vast regions of which are a material vacuum far more perfect than can be produced on Earth? It was only with the advent of Einstein's special theory of relativity that the solution, treated in the next chapter, slowly became recognized. But before we leave the present subject of Maxwell's achievement, it is worth examining some of its implications.

## FRAMED ICONS AS ARTISTIC COMPOSITION

Recall our discovery that within the frame of figure 17 is a *composition* in a truly conventional sense. You may even quite correctly imagine arrows pointing among the Maxwell equations, tracing *paths of mathematical logic* among them and enclosing the centrally placed equations—just as artists contrive to

guide the eye through a painting, whether abstract or representational, using various devices of art.

The successive "brush strokes" represented by each of those equations at the corners of the picture are steps in our understanding of electromagnetism. Each stands for a decisive statement directed toward the creation of a coherent composition. And the crucial step, the final piece of the picture puzzle, requires the stroke introduced in 1865 by Maxwell, namely the last term of the equation shown in the lower right corner of the picture. This mathematical term provides the final complement to all of the previously acquired knowledge of classical electricity and magnetism. In this final form, the "painting" in figure 17 can be appreciated as a fully integrated composition representing classical electromagnetism.

In its coherence and organic unity, the drama of the Maxwell icons is, of course, recognizable not only by physicists, who can read their internally consistent, quantitative implications. Its aura may also be recognized by anyone who has encountered the light from the Milky Way in a moonless desert sky. It is not uncommon to see T-shirts with the Maxwell equations embossed on them. Prefacing the equations is the statement "And the Lord said" and following them is "Let there be light!"

# 7 Einstein's Relativity and the Escape from Relativism

In the seventeenth century, building on the work of Johannes Kepler and Galileo Galilei, Isaac Newton discovered laws describing the motion of material objects. And he showed that the law describing the fall of an apple from a tree also applies, with mathematical precision, to the "fall" of the moon as it negotiates its orbit around the earth.

The moon does indeed fall as it moves around the earth, following the same laws as for a baseball moving along its arc before falling to the ground. But, of course, the ball would have to be given a much greater speed than any pitcher can muster in order to place it in orbit around the earth. (And including air resistance in the stew allows the pitcher to throw curveballs.)

If you are sitting in an inertial reference frame, say in a car moving with constant velocity, you cannot tell that you are in motion if the windows are obscured. You feel no forces that could offer such clues. From your point of view, you can throw a ball straight up into the air and it will come back to your hand as it would if you were standing still at the roadside.

What does it mean, anyway, to claim to be standing still? The earth is rotating on its axis and revolving in its orbit about the sun, and the solar system, in turn, is tracing a path in our galaxy consisting of hundreds of billions of stars. This brings to mind the story, told by Galileo Galilei (1564–1642), of the sea captain who decided to determine the speed of his sailing vessel by having a sailor drop a rock from the top of the mast. Given the distance of the rock's landing point from the foot of the mast and knowing the measured time of fall, the clever captain hoped to determine the ship's speed. But to his surprise, the rock landed at the foot of the mast. Strangely enough, he would not have been surprised at this result if the ship had been at anchor and supposedly at rest. (A minor quibble is explained in the notes.)[1]

The point is that all inertial ships, boats, or cars are equally good plat-

forms; different inertial observers experience the same laws of motion and agree that all their observations are consistent with Newton's laws. Only if a car with blackened windows were to accelerate, thereby becoming a non-inertial frame, would there be motion clues, such as pressure on seat backs, distinguishing observations from those of inertial observers.

Notice that a symmetry is operating here. The physical laws offer no information singling out any particular inertial observer; there is no privileged inertial observer. This is the principle of relativity. The idea embodied in relativity entered the physics literature long before the appearance of Einstein's special theory of relativity, which we will meet shortly.

Einstein recognized that Maxwell's laws of electromagnetism seemed to require abandoning the traditional principle of relativity; electromagnetism appeared to introduce the privileged observer, one who, alone, could correctly experience physical laws. Where does this strange possibility come from? As you saw in chapter 6, the wave equations introduce for electromagnetic waves a definite velocity $c$, which is about 186,000 miles per second (about 330,000 kilometers per second). But which observer measures this particular value? If one admits the need for a material medium to carry a light wave, then shouldn't different observers measure different wave velocities? (See figure 18.)

So who is the privileged observer? It would seem that, unlike the case for the laws of Newton, Maxwell's electromagnetism releases the genie, who insists that we give up a precious symmetry idea: that physical law is the same for all inertial observers. Electromagnetism would seemingly introduce a relativism that had not been present in Newton's laws of mechanics.

Einstein insisted that the laws of physics should "make sense," that is, obey symmetry among all observers, not only for Newton's laws but also for all the laws of physics. Einstein's theory provided an escape from the relativism that had loomed for over a generation over the apparent implications of Maxwell's work. The path toward Einstein's recovery of that symmetry was an arduous one indeed, for it required a reexamination of formerly dearly held ideas about space and time, leading to remarkable breakthroughs in understanding, with consequences even to the present.

So much for cocktail-party grasp of the term *relativity* and the misleading slogan, "Everything is relative, says Einstein," a misconception held by some even now. His assertion was to the contrary. The misunderstanding led him to declare that he should have called his theory "invariance theory" rather

than relativity. He also said, at one point, in frustration over the drift of our so-called civilized society, that he should have been a plumber. It's not clear that he would have been as successful in that demanding occupation, but he might have found gainful employment more readily at the beginning of his career.

## WAVES AND THE ETHER

To make clear why relativism and its disquieting implications arose in the context of Maxwell's electromagnetism theory, let us look at familiar wave behavior. When a stone is thrown into a pool, the water disturbance spreads as a wave in ever widening circles. Such familiar experience would suggest, as noted earlier, that a wave without its supporting medium is inconceivable: the wave is, after all, commonly understood to be a disturbance of that medium.

This was the mindset that scientists such as James Clerk Maxwell brought to the question of the medium in which electromagnetic waves propagate. Maxwell and his contemporaries attempted to imagine plausible mechanical models for the postulated invisible and tenuous but, at the same time, unimaginably dense medium, which they called the *ether*.[2] You can readily appreciate their profound commitment, given their psychological and intellectual inheritance of familiar phenomena, to the concept of an ether medium pervading space. Here is Maxwell's 1873 expression of faith in the existence of the ether: "The vast interplanetary and intergalactic regions will no longer be regarded as waste places in the universe . . . When a molecule of hydrogen vibrates in the dog-star, the medium receives the impulses of these vibrations; and delivers them in due course, regular order, and full tale into the spectroscope of Mr. Huggins, at Tulse Hill."[3]

It seems a pity that such a beautifully expressed prediction should not be realized. But Einstein's revolutionary vision, as expressed in his special theory of relativity, pointed to the necessity, not only theoretical but aesthetic as well, of discarding the ether hypothesis.[4]

To reexamine the ether question, let us start by measuring the speed of water waves going past an anchored motorboat and then comparing the result with those for the boat moving first with the waves and then against the direction of the waves (figure 18). Clearly you would record different numbers: the measured wave velocity in the medium depends on the motion of the

Figure 18. Motorboat and water waves. *(a)* The boat is at anchor. *(b)* The boat is moving toward the oncoming waves. The speed of the waves, as measured by the occupants of the boat, is now greater. The boat bobs at a greater rate. *(c)* The boat is being chased by the wave motion. The observer in the boat sees the wave speed as reduced. In fact, if the motorboat should match the speed of the waves, the occupant would see the wave crests remaining in fixed position and imagine the wave speed to be zero.

observer relative to the medium, and only the observer in the *anchored* boat would read the true wave velocity.

In 1887, two experimenters, Albert Michelson (1852–1931) and Edward W. Morley (1838–1923), sought evidence for motion through the hypothesized ether, the medium in which electromagnetic waves supposedly move. But now it was the motion of light waves through the postulated ether, rather than water waves through water, that would be detected. And rather than a motorboat, Michelson and Morley would use the earth itself as the vehicle coursing through the ether.

## THE EARTH AS MOTORBOAT

Michelson and Morley adapted a special instrument, called an interferometer, to detect the "ether wind," the evocative name for the effect of sailing through the ether medium. They expected different readings to be recorded for the wave velocity as different directions of motion were sampled. Since the interferometer was exquisitely sensitive to detection of possible changes in light velocity, the effect on motion through the ether would presumably be discovered. Despite the fact that the apparatus was capable of detecting a change of light speed many times smaller than would be caused by the earth's motion around the sun, no change in light speed was found. That is, the result was unlike experience with a motorboat in water waves.

Michelson thought that his null result, the inability to detect motion through the ether, simply indicated a failure on his part. The problem with a null measurement is that absence of evidence is not evidence of absence. For many years thereafter, however, increasingly sophisticated experimental efforts by several researchers met the same fate.

Among the many attempts to account for the failure to detect the motion were notable theoretical efforts by George F. Fitzgerald (1851–1901) and Hendrik Lorentz (1853–1928). However, their ad hoc hypotheses had insufficient physical justification. The Fitzgerald hypothesis was inconsistent with known properties of matter. The Lorentz contribution provided a rule, now called the Lorentz transformation, by which different observers could compare notes but no physical rationale for its form. A satisfactory resolution of the dilemma would require not a patchwork but a revolutionary new insight.

The failure to detect a motion through the ether did not surprise Einstein. Quite independently of the Michelson-Morley results, he felt that, on fundamental grounds, there should be no detectable motion of electromagnetic waves relative to the postulated ether. He argued that the notion of an ether medium for such waves should be abandoned, for otherwise only a privileged observer, one in that presumed at-rest frame of reference anchored in the ether medium, would be privy to the correct laws. Like the person in the anchored motorboat, only the privileged observer could determine the correct value for $c$; only he could observe the laws of electromagnetism correctly.

Einstein's total rejection of the notion that such relativism would characterize the natural order motivated his search for a more aesthetically appealing solution. He chose as a starting point, that is, as his basic premises, the following: All of the laws of physics should be the same, "invariant," for all inertial observers, that is, in all inertial frames of reference. Then, necessarily, the speed of light should be the same for all inertial observers, whatever their relative motions. From this seemingly simple but deceptively revolutionary beginning flow all of the consequences of the special theory of relativity, including the total revision of our ideas of space and time and of energy and matter.

## CONSTANCY OF THE SPEED OF LIGHT

From Einstein's postulate that all inertial observers measure the same value for the speed of light $c$, he was able to derive new rules permitting different observers to correctly compare notes for electromagnetism as well as mechanics. While Lorentz had introduced the transformation rules as an ad hoc patchwork device for addressing the null results of Michelson and Morley, they now fell out as a natural consequence of Einstein's postulate that the speed of light is the same for all observers.

The theory takes $c$ to be the ultimate velocity, experienced only by massless particles, such as that of light (the "photon"); no material object can equal light speed because infinite energy would be required to take the object to that speed. And, equally surprising, all observers, even if they are moving relative to each other at great speeds, find that light passes each of them at the same speed $c$, 186,000 miles per second! Everybody measures the same value

*c* for the speed of light, and everybody gets the same laws of electromagnetism. The privileged observer is dispensed with.

But how can it be that you measure the same value for *c* no matter what may be your own state of motion? To this, Einstein points out that you do not measure speed directly. Rather, you determine it by measuring a distance and the time it takes to cover that distance—say, so many miles per hour. Einstein's theory calls for a revision of the conventional view of distance and time, that is to say, our concepts of space and time, as perceived by different observers.

The special theory of relativity not only removes the cloud hanging over classical electromagnetism. It also gives laws of motion applicable not only for low speeds, in agreement with Newton's laws, but also for those approaching the speed of light, where Newton's laws of motion fail.

## DECIDING ABOUT SIMULTANEOUS EVENTS

We normally experience very small speeds compared with that of light. Even a satellite circling the earth typically travels at only about 25,000 miles per hour. Compare this with the speed of light, 186,000 miles per second, about 27,000 times faster! Light speed is so fast that for most common situations we can neglect the fact that it is not infinite in value. But for very rapid phenomena, the fact that light speed is not infinite needs to be taken into account.

The way we commonly experience time needs to be reexamined. The question of simultaneity of events when speeds approach that of light is basic. To address this question, Einstein invoked a visual image of what he liked to refer to as a *gedanken* (thought) experiment. It was characteristic of Einstein to find visual images embodying the essence of a physical mystery. Those images capturing the thought experiments often embodied new ways of looking at seemingly ordinary phenomena that, in fact, represented the germ of new discovery.

Figure 19 shows why observers in different near-light-speed rocket ships may disagree about the simultaneity of events. Imagine that in the opposite two upper corners of a long rocket ship are placed instruments that can emit lightning flashes. In figure 19, Ali, standing in the center of the ship, determines with her measuring instruments that she received the flashes simultaneously. Meanwhile, Zach, standing in the center of another rocket ship trav-

Figure 19. Rocket ships and simultaneity

eling in the same direction at very great speed relative to Ali's ship, also can see the flashes of light from Ali's ship. But Zach finds that the flashes were by no means simultaneous. Owing to his very rapid motion relative to Ali's rocket ship, his observation is that the two spatially separated signals in Ali's ship were received at measurably different times. Only if light speed were infinite would Ali and Zach agree.

Because relative speeds of different observers usually are small compared to that of light, the observers usually do not disagree about simultaneity. But at speeds near that of light, the question of simultaneity of spatially separated events (keep in mind that the spark sources were at opposite ends of Ali's car) becomes dependent on who is doing the observing. The notion that time is absolute, implicit in Galilean relativity, must be abandoned.

So now imagine clocks fixed in each of two rocket ships. In each ship, an observer's clock will disagree with the elapsed time recorded by the other's clock; each observer will decide that it is the other ship's clock, compared to his or her own, that is running slow. From Ali's point of view, Zach's rocket ship is streaking past with speed **v** and his clock is running slow—the closer **v** to light speed $c$, the greater the deviation. Zach's point of view is that it is Ali's ship that is moving with speed **v**, in the opposite direction, and it is Ali's clock that is running slow. The effect, in relativity parlance, is called *time dilation*.

Since a clock is nothing more than a means for marking off regular events, the time dilation effect could equally well refer to the decay of radioactive particles, the heartbeat, or the doubling rate of living cells. So, for example, Zach

would decide that Ali, in the other rocket, was aging more slowly—but Ali would decide the same about Zach! Again, this all seems so strange to us because it is so foreign to our familiar experience; we do not normally make observations involving such speeds.

The Einstein postulates provide a new prescription not only for time duration but also for lengths. Lengths observed in another reference frame are observed to be shortened relative to lengths at rest in our own frame. This effect is called *length contraction*.

Summarizing, an observer at rest relative to a rocket ship traveling at speeds near $c$ reads the ship-bound clock to be running slow and the stick, aligned in the direction of motion, to be shorter than the one bound to his reference frame.

Given the effects on time duration and length measurement, it is no surprise that the compounding of velocities will be affected as well. In Newton's physics, the familiar rules of Galilean relativity operate. Say you throw a ball forward from a moving car. If you ask the opinion of an observer standing by the side of the road, the speed of the ball is simply the sum of the separate speeds of the car and that of the ball, as measured from the car. But this is not the case in special relativity. The new rules must accommodate the fundamental postulate of special relativity that the speed of light be the same for all observers, no matter what their separate velocities.[5]

## CLOCKWORK OF THE MUON

Actual demonstrations of some of these effects are mind boggling. Consider one showing time dilation. Subatomic particles commonly attain relativistic speed. Even the electrons in TV tubes move at speeds that can show measurable relativistic effects.

The behavior of particles called muons having speeds very close to $c$ provides an interesting test of relativity. These unstable particles can be created in high energy particle accelerators and by the action of so-called cosmic rays, high-energy protons along with some heavier particles, from outside our solar system. The muons are created as a by-product of collisions between cosmic ray protons and nuclei of atoms in the atmosphere.

We are protected from the lethal effects of cosmic rays by the shielding

Figure 20. Muons and time dilation. High-energy particles from outer space ("cosmic rays") entering the earth's atmosphere give rise to subatomic particles called muons. The short lifetime of these unstable particles should preclude their arrival at the earth's surface in the numbers observed.

effect of the atmosphere, but deep-space travelers would not be so fortunate. The incoming high-energy proton hits a nucleus at an average altitude of about 70,000 feet, after which cascades of gammas (high-energy photons) and electron-positron pairs are formed at ever decreasing energies. Also produced by that impact of the cosmic ray proton is a pion, which decays straightaway into a muon.[6]

An observer at ground level would read a clock stuck to the muon racing toward ground to be slow compared to the one that is stationary in her laboratory; she would record the "tick-tock" intervals as being longer than those she measures for her ground-based clock. But how is such a measurement to be made? How do you attach a clock to the muon? The muon's characteristic decay time represents a natural clock moving with the muon, an unstable

particle having a mean lifetime of about 2 microseconds, two millionths of a second. So, as illustrated in figure 20, the ground observer would expect that, for muons moving rapidly down toward him, the decay would be delayed (as determined by his own clock) and many more would be detected arriving at the earth's surface than otherwise expected.

Indeed, muons formed at the top of the atmosphere are detected in abundance at the earth's surface, owing to the effect of time dilation: our ground observer reads the muon's "clock" to be running slow. Such effects in many other experiments using particle accelerators in the laboratory have also shown, in quantitative detail, consistency with the predictions of relativity.

## GENERALIZING RELATIVITY

Although inertial observers, such as passengers in vehicles moving at constant speed in a straight line, have no sensation of motion, if a car is accelerated its occupants are aware that they are moving. Distinct forces then seem to come into play, informing the occupant, through the pressure from her seat back, for example, that she is in motion. She would become aware that her reference frame had been singled out relative to those in unaccelerated motion. A deviation from observer-symmetry would be identified.

Einstein felt that it should be possible to find a broader formulation of the principle of relativity than in Newton's physics and in his own special theory of relativity, one that would incorporate accelerated frames as well as constant velocity (inertial) ones. He sought physical law so generalized that it would remain invariant in all reference frames. That search led in 1915 to the general theory of relativity, which has deepened our understanding of gravitation and, in the process, broadened our knowledge of the cosmos.

While it is commonly understood that the special theory (1905) would have been discovered within a few years if Einstein had not done so, it is also widely acknowledged among physicists and historians of science that the general theory was not similarly anticipated. While curved geometries had been developed by mathematicians such as Georg Friedrich Bernard Riemann (1826–66), the physical ideas in the general theory were thoroughly revolutionary.

Let us first say a word about Newton's theory of gravitation mentioned

at the beginning of this chapter. Aristotle had believed that more massive falling bodies will fall faster than lighter ones. That would seem to be a common-sense notion. But it is incorrect, as Galileo and others have shown.

This can be seen from Newton's laws. His second law of motion says that the force needed to accelerate a material object by a certain amount is proportional to its mass. Newton's law of gravitation makes a separate comment: Describing the force due to gravitation, it says that any two masses (Earth and Sun, Moon and Earth, a baseball and a pitcher) are attracted to each other by a force that depends on the product of their masses and inversely on the square of their separation. For example, if one of the two masses is doubled, the force becomes twice as great, and if the separation between masses is doubled, the force becomes one-quarter as great. Of course, the gravitational force is so weak that we commonly notice its effects only when one of the masses is very large, such as the mass of the earth.

These two Newton's laws can be used to show readily that freely falling bodies drop neck and neck, if you exclude the effect of friction, which might act differently on the two objects. The simplest way to show this is to do a little calculation.[7]

The proof assumes the mass $m$ in Newton's law of motion is the same as that describing the falling body. But, from the point of view of Newton's laws, the two masses seem to come from very different directions. The equality of the two masses has been demonstrated. But why should it be so?

The conundrum was one of Einstein's preoccupations leading to the development of his general theory of relativity. He was motivated by the centrality of what he termed the principle of equivalence, which says that the effects of gravity and acceleration cannot be distinguished from each other.

As you have already seen, Einstein often gained insight from so-called thought experiments, which generally involved visualizing crucially telling scenarios. The thought experiment mentioned earlier, involving the test of simultaneity in the moving spaceships, was such an example. The following one embodies the principle of equivalence. In one variant of this visual exercise, you are to imagine a passenger floating in a freely falling elevator. In this free-fall acceleration, he would have no way of sensing that the force of gravity had not been suspended.

Einstein's recognition led him, after profound investigation, to recognize the gravity force as an expression of the curvature of "space-time." A simple

Figure 21. Simulation of space-time bending. The *dashed lines* show the distortion of the plastic sheets.

demonstration providing a crude analogy may be useful here. Imagine placing a sheet of plastic wrap horizontally under the surface of the water in a fish tank, as illustrated in figure 21. While a heavy ball placed on the nearly invisible sheet causes the sheet to deform, the warping is nearly undetectable to the observer. If a much smaller ball—say, a BB—is then introduced, it will mysteriously "gravitate" toward the larger sphere. The two spheres will move toward each other but, owing to the disparity in masses, the larger sphere's motion may here be neglected. You could choose to give the BB an initial motion perpendicular to the line joining the two spheres, in which case the BB would tend to orbit the larger sphere. Of course, the demonstration illustrated in the figure is intended only as a metaphor for the shaping of space-time by mass-energy.

An airline pilot chooses to follow the shortest distance between two points on the globe of the earth, not a "straight line" as perceived on a flat surface. So, too, the path of a planet—or the path of light itself—follows a "shortest path" in space-time. For example, guided by the model offered by the fish-tank experiment, we can imagine the earth as orbiting in the puckered space-time carved out by the mass-energy of the sun. Similarly, the path of light

from a star must appear to bend toward the earth as it passes the sun in a graz-
ing path, on the way to our eye or telescope, as in the often-used illustration
shown in figure 22.

This prediction of the theory provided one of its most dramatic early confir-
mations when a solar eclipse in 1919, four years after publication of the gen-
eral relativity theory, allowed such a starlight deflection to be observed. The
predicted deflection of the light path, small but measurable (less than 2 seconds
of arc), was essentially confirmed. The announcement of this dramatic result in
newspapers around the world led to Einstein's immediate worldwide renown.

The general theory also accounted for a mystery of 60 years' standing, an
anomaly unexplained in Newton's gravity theory. Since Urbain Leverrier's obser-
vation in 1855 of an advance in the perihelion (the closest point of a planet's
orbit to the sun) of the planet Mercury, the phenomenon had remained unex-
plained. In Newton's gravitational theory, in which the force decreases with
the increase of the square of the separation distance between the sun and the
planet, the orbit should close on itself. But in the Einstein theory there is a
deviation from that inverse square law, with the effect that there is a change
of angle in each circuit of the orbit. The effect is pronounced for Mercury,
since it moves relatively rapidly in a highly (nearly) elliptical orbit. Einstein's

Figure 22.  Bending of starlight grazing the sun

theory predicted an anomaly in Mercury's orbit in correct agreement with observations, thereby solving the 60-year-old mystery. A large number of reasonably accessible descriptions of general relativity are available for further exploration.[8]

Many discoveries fueling the current excitement in modern cosmology represent confirmations of the general relativity theory. Among phenomena anticipated by the theory are so-called black holes, for which evidence now exists. As you saw earlier, these are celestial objects having mass so densely packed that even light cannot escape. The understanding of effects attributable to space-time curvature, including the possible existence of black holes, has revolutionized astrophysics—not to mention the world of science fiction.

The Nobel laureate Subrahmanyan Chandrasekhar observed:

> In my entire scientific life, extending over 45 years, the most shattering experience has been the realization that an exact solution of Einstein's equations of general relativity, discovered by the New Zealand mathematician, Roy Kerr, provides the absolute exact representation of untold numbers of massive black holes that populate the universe. This "shuddering before the beautiful," this incredible fact that a discovery motivated by a search after the beautiful in mathematics should find its exact replica in Nature, persuades me to say that beauty is that to which the human mind responds at its deepest and most profound.[9]

# 8 Form in Impressionism and Postimpressionism

The last few chapters have shown, with specific examples, the role of symmetry and broken symmetry in directing discovery and shaping composition in theories of physics. We saw the increased emphasis on form as a guide to discovery about the physical world. Analogously, the present chapter and the next show the increasing role of formal elements in art, starting in about the last quarter of the nineteenth century, which saw the advent of Impressionism.

## IMPRESSIONIST ELEMENTS IN COMPOSITION

The style of painting that came to be identified as Impressionism was characterized by a distinct application of artistic elements and design. As practiced by Claude Monet, Camille Pissarro, Mary Cassatt, Berthe Morisot, and others, sharp realism frequently gave way to impressions dictated by light, color, and the dissolution of well-defined shapes. Another impressionist innovation was the departure from what had usually been regarded as appropriate subject matter, such as heroic themes or people of acknowledged consequence. Ordinary people were captured in common activities, often in the open air.

To enhance the effects of light on surfaces, whether in a landscape or in an interior scene, the artist selected hues, many of which had not been available to artists of much earlier periods, that were dominated by high tones. Impressionists frequently promoted the effects of shimmering light and color vibration by placing small dabs of different harmonious hues side by side, which is one of the sources of the pleasure experienced by viewers of impressionist paintings.

Placing different pigments side by side rather than mixing them with the brush has been assumed to have the same effect as color mixing by the eye.

In studying the effect of side-by-side strokes of color, however, analysts have frequently confused the distinct effects of mixing color pigments versus the mixing of different colors of light. As noted in chapter 5, color mixing for light is different from that for pigments, as photographic and TV technicians well know. Side-by-side dabs of colored light impinging on the retina of the eye do not mix like pigments on the canvas. For example, while pigment mixtures of the primaries blue and yellow give green, this is not necessarily the case for the mixture of blue and yellow light (see Maxwell triangle at www.handprint.com).

This confusion between the visual effects of pigment and light mixtures appears in some analyses of the works of Georges Seurat and of a few others who followed briefly in his footsteps. Seurat pioneered a painting technique known as Pointillism, or Divisionism—which made use of closely spaced points of different colors—in composing his paintings, one of the most well known of which is *Sunday Afternoon on the Island of La Grande Jatte* (1884–86, not shown).

Not all of the participants in the impressionist shows, eight of which took place in the period 1874 to 1886, painted in the traditionally impressionist manner. Claude Monet, the quintessential impressionist, worked increasingly in the style from the early 1870s until his death in 1926. Camille Pissarro participated in all eight impressionist shows and remained loyal to its point of view. Others later abandoned Impressionism, as did Paul Cézanne in about 1878.

The movements commonly labeled Impressionism and Postimpressionism are not entirely distinct chronologically. To further complicate distinctions suggested by the terms, many of the artists identifiable as postimpressionists did not share a common style or artistic program. What some of those artists did share was a withdrawal from the dissolved forms of Impressionism after having adopted the style for a time. But the revolutionary trend toward Modernism continued to be expressed by the postimpressionists, for example, in the frequent use of unnatural color and shapes by some of them.

Edouard Manet's *Boating* (see figure 14) was introduced in chapter 4 as an illustration of the balance of forms. This 1874 painting is an example of the impressionists' style. The painting demonstrates characteristic subject matter and technique, an informal scene laid-in freely by the brush, without the traditional concern for sharp definition of outline and solidity of shapes.

Some unifying elements common to Impressionism, such as the emphasis on hue as a unifying element in composition, are not routinely used as

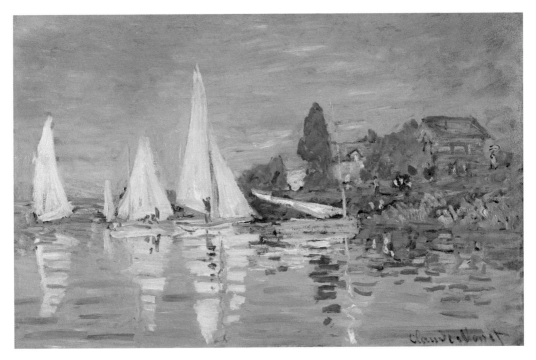

Plate 10. Claude Monet, 1840–1926, *Regatta at Argenteuil,* c. 1872, oil on canvas. (Getty Images, The Bridgeman Art Library)

organizing devices elsewhere. In Hopper's work, for example, the red of a chimney in a seascape may not necessarily find itself echoed elsewhere in the painting. This is not typically the case in Impressionism.

In Monet's *Regatta at Argenteuil* (plate 10), the distribution of reds and ivory-white, carried not only by water reflection but also in the spit of land and dockside, provide a unifying role. Flicks of the brush apply dabs of red to the boats and occupants and of white to the piece of land. Notice the choice of high color intensity in the sails and houses.

In another clear application of impressionist devices, a seemingly wanton freedom of brush and consistently pursued suppression of distinct forms promote compositional unity. Notice the intentional uniformity of roughly laid in, horizontal dabs of paint in the water reflections of the sails, trees, and red houses.

When you see the predominantly horizontal brush strokes in sea and sky, as well as the strong horizontal bands consisting of water, sky, and land, you are prepared to find the painter's counterpoint. So, you may ask, where is it? As if in response, Monet tells us to look at rebalance of horizontal elements

by strong vertical forms. The sails and trees, along with their reflections, connect all three horizontal bands.

But you may still have a quibble: The right side is dominated by red and the left by ivory. While this may have been the scene he was given, it may have bothered Monet. So, as you may have noticed, he invented a bit of redress. The leftmost sail as well as its reflection have a bit of red. A touch of red also is evident in the other sails and their reflections. Some red also shows up at the left horizon. Notice also touches of green peeking out toward the left side. Finally, if you examine the change in color of the sky, you will see that the right side has an off-white tone, while the left is more violet, with red having been added there. It is as though Monet is saying, I need to rebalance the hues of the houses and sails, separated on the right and left sides of the canvas.

Pierre-Auguste Renoir's *Woman Gathering Flowers* (c. 1872) shows some of the same impressionist touches, such as the characteristic capture of a subject in an "informal moment," the expected suppression of well-defined shape, the emphasis on color vibration, and the freely applied brush (plate 11). Contributing further to the compositional unity is the repetition of hues virtually everywhere in the picture, as, for example, in the blue-violet of the parasol, grasses, sky, and landscape elements on the horizon. There is a similarly broad distribution of yellow, green, and rose.

Incidentally, notice also some of the more conventional artistic devices. The woman, placed somewhat off-center to avoid a static arrangement, is nevertheless clearly the dominant object. She is the largest form and is highlighted by the lightest tints adjacent, for contrast, to dark blue shadow. A frequently used strategy involves identifying the center of interest by applying the lightest lights and darkest darks, and this is the case for the figure.

It is no accident that Renoir chooses to have the woman's head and hat extend—but barely—above the horizon. The off-white of the hat helps give artistic weight to the device: notice that the sky is a darker blue behind the hat than elsewhere. In this way, her vertical form definitively binds all three horizontal bands, those of the meadow, the darker band beyond, and the sky.

A subservient object, the parasol at the lower left, rebalances the off-centeredness of the dominant figure. The handle points from the woman, who is the center of interest, thereby helping carry the eye around the painting. Artists sometimes find a problem with a lower corner, when concerned with having the observer's eye track properly. In this painting, the eye starts

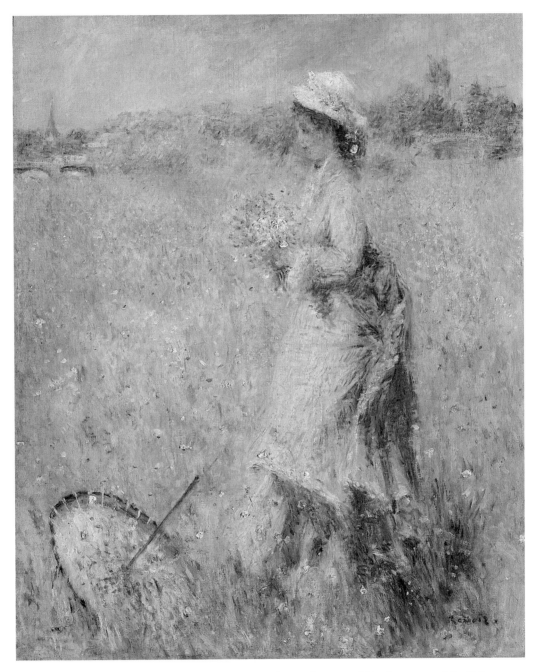

Plate II.  Pierre-Auguste Renoir, 1841–1919, *Woman Gathering Flowers,* c. 1872, oil on canvas, 28 × 22 in. (Sterling and Francine Clark Art Institute)

at a high point on the figure, tracks downward nearly to the very bottom of the picture, and then would leave the painting but for the turn offered by the parasol.

Recall the dilemma of the art student whom we met in an earlier chapter. I should mention that it finally became clear that she was concerned about a corner of her painting—the lower left corner, as it happens. One of the suggestions made by an observer was that she might put a chair there. Renoir may well have had similar thoughts in coping with placement of the parasol.

The foregoing examples, while displaying unique artists' voices, all offer familiar variations on an underlying theme. Elements and principles of art are used to create complementary deviations from symmetry dedicated to finding an overall coherence.

## THE ARTIST'S FINGERPRINT IN BRUSH AND TEXTURE

The important role of brush and texture in fostering compositional unity, already evident in Monet's work, shows itself as well in the Renoir. Renoir's particular "trademark brush" appears in the blue-violet striations of paint in the grassy field. It is even more palpable in plate 12, *Child with a Whip* (1885). While texture of brush is one of the unifying compositional devices for many artists, the present examples are particularly characteristic of Renoir's hand. Elongated striations reveal the bristle-track of the brush's passage. See, for example, the pull of the brush leaving the Renoir "fingerprint" in the child's dress and in the background. The Renoir brush is so distinctive that, in many of his paintings, inspection of only a small section is sufficient to identify the artist or, of course, a derivative painter attempting to imitate him.

The works of Van Gogh offer prime illustrations of composition unified by brush, especially in his 1886–90 period. In these last 4 years of his 10-year career as a painter, and the last 4 years of his life, he favored expressive color phrases applied using a brush loaded with broad ribbons of paint.

Shown in plate 13 is the painting *Wheatfields with Cypresses* (June 1889). It is obvious that brush assumes a prominent role as a word in the compositional vocabulary of this painting. That is, it serves as one of the organizing elements that bind the beautifully choreographed phrases into a unified whole, the integrated artistic statement. The sweep of the Van Gogh brush, whether

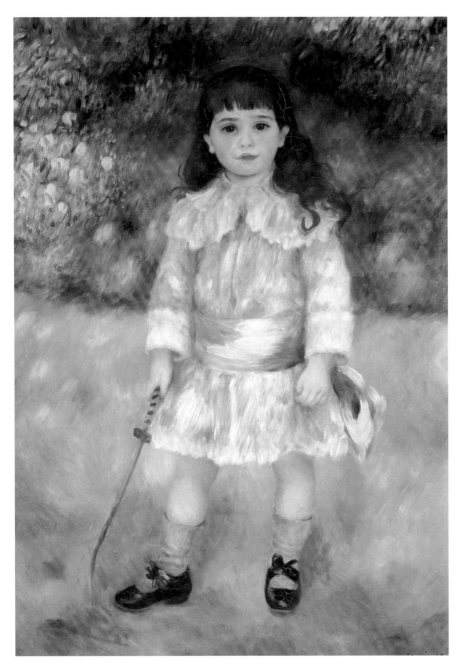

Plate 12. Pierre-Auguste Renoir, 1841–1919, *Child with a Whip,* 1885. (Hermitage, St. Petersburg, Russia. Photo by Art Resource, NY)

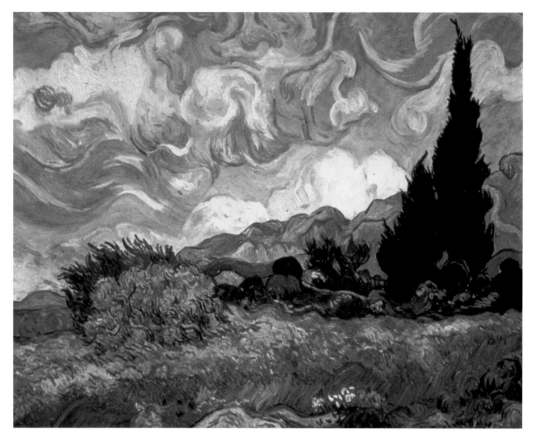

Plate 13. Vincent Van Gogh, 1853–90, *Wheatfields with Cypresses,* 1889, oil on canvas, 28¾ × 36¾ in. (Getty Images, Time and Life Pictures. Photo by Allan Tanenbaum)

in still life, portraiture, or landscape, carries a peculiar dynamism. The emotional energy is evident everywhere in the painting: the writhing shapes of the cypresses, the clouds, the hills, the grove of trees at the left, and the wind-blown wheat field.

The broad distribution of related hues, evident in the subdued repetition of green, blue, and yellow phrases, further contributes to the compositional unity. The central theme is borne by the dominant shapes, the large cypresses near the right side of the canvas. The subservient forms of shrubs, distributed all the way to the left horizon, help rebalance artistic weight.

A particularly striking example of the power of surface texture imposed by brush or painting knife is an early Cézanne from the 1860s, a period when he still painted using a dark palette. While suggested in the reproduction of

Plate 14.  Paul Cézanne, 1839–1906, *The Artist's Father, Reading "L' Evenement,"*
1866, oil on canvas, 78⅛ × 47 in. (Collection of Mr. and Mrs. Paul Mellon.
Image © 2007, Board of Trustees, National Gallery of Art, Washington, D.C.)

Plate 15. Camille Pissarro, 1831–1903, *The Vegetable Garden with Trees in Blossom, Spring, Pontoise,* 1877, oil on canvas. (Getty Images, The Bridgeman Art Library)

*Portrait of Louis-Auguste Cézanne* (the artist's father, painted in 1866) (plate 14), the original, which hangs in the National Gallery of Art in Washington, D.C., shows its full muscularity and vigor. The sweep of impasto (from Italian, meaning paste, and signifying thickly applied paint) in this Cézanne portrait, here applied as though with a painting knife or broad brush, is one of the dominant unifying elements in the composition.

Camille Pissarro convinced Cézanne to change the dark tones and heavy brush application characteristic of his early period, the 1860s into the first years of the 1870s. He began to paint *en plein air* (outdoors), with a lighter brush, and with brighter hues. For several years thereafter, he painted with the impressionists and frequently with Pissarro, one of the most steadfast of

the impressionists. Pissarro had a similar influence on Van Gogh, whose early paintings also were rendered in dark tones before about 1886. (Van Gogh's entire life in painting lasted from about 1880 until his death in 1890.)

I saw an interesting exhibition of Camille Pissarro paintings in 2007 at the Walters Art Museum in Baltimore, Maryland. It featured the development of his painting style in the decade from 1864 to 1874, the year of the first impressionist show. Among the things clearly indicated is the change in Pissarro's brush technique by the end of that period. In some of his paintings from the 1870s and onward, it is almost as though the dabs of paint are applied with the tip of the brush.

Plate 15 shows a Pissarro, *The Vegetable Garden with Trees in Blossom, Spring, Pontoise,* painted in 1877 (not in the Baltimore show). Here is an example of an identifying stroke contributing to compositional unity. One can almost see the bearded Pissarro, squinting eyes close to the canvas, carefully applying the points of paint in this work. It is easy to understand how it is that Pissarro, under the influence of Seurat, turned to Pointillism for a brief time.

## THE POSTIMPRESSIONIST RECOVERY OF WELL-DEFINED SHAPES

How many of us have wanted to stand, invisible, behind an artist at work, comparing how our eyes and his might encompass the same scene. It would be fascinating, for example, to witness translations from the eye, hand, and mind of an artist like Paul Cézanne into a coherent and unified vision. As it happens, such studies have been made. Erle Loran (1970), John Rewald (1986), and Paul Machotka (1996) found and photographed many of the actual locations where Cézanne had set his easel and painted in the open air. In Machotka's words, "When [Cézanne] painted a landscape he . . . reconciled two typically independent aims: to present the motif's structure and sensuous tone clearly, and *to create an object with a rich inner coherence* . . . And one can see in the landscapes *a passionate response to what his eye had grasped and understood.*"[1]

An excellent illustration of this strategy is shown in plate 16, Paul Cézanne's beautiful *The Great Pine* (c. 1889). It is possible to recognize the internal artistic dialogue that Cézanne imposed in order to create a balanced, harmonious, and unified composition. Consider some of the artistic devices and strategies

Plate 16. Paul Cézanne, 1839–1906, *The Great Pine,* c. 1889, oil on canvas. (Getty Images, The Bridgeman Art Library)

used here. Notice the short, parallel, and diagonal strokes present virtually everywhere. Cézanne used this signature brush mark as a device for imposing a unifying matrix on his compositions. The brush changes to larger patches in his late landscapes. See, too, that the diagonal strokes pointing upward and to the right are counterbalanced by the oppositely sloped trunks of most of the trees. The logic seems to be based in art rather than reality: The windswept look of the crown of the large pine seems to make little sense when compared with the opposite lean of the trunks. But Cézanne's choice does create an artis-

tic balance. Interest is raised by the wide range of color values and the variation of hues from yellow-green through blue-green. Here again is a demonstration that in a masterwork the assembled voices weave a coherent message.

Let us look at an example of Cézanne's still lifes, which he frequently chooses as subjects. Perhaps part of the reason for Cézanne's affinity for still life is the freedom it provides to freely arrange objects—knives, fruit, bowls, and bottles—to express his views about the balance of forms and colors in a two-dimensional space. It seems that, for Cézanne, these commonplace objects have an artistic existence no less compelling than his landscapes. Consider these comments by John Rewald, among the preeminent Cézanne scholars of his time. "One rainy day, Louis Le Bail watched Cézanne compose a still life: a napkin, a glass containing a little red wine, and peaches. 'Cézanne arranged the fruits, contrasting the tones, one against the other, making the complementaries vibrate, the greens against the reds, the yellows against the blues, tipping, turning, balancing the fruits as he wanted them to be, using coins of one or two sous for the purpose.'"[2]

Plate 17, *Still Life with Milk Jug and Fruit* (1886–90), illustrates Cézanne's abandonment of the traditional modeling of shapes. A common strategy is to give shape the illusion of three-dimensionality by introducing an underpainting of body shadow before adding color; light and shade are commonly used to mold shape. But Cézanne uses broad slabs of color alone for shaping volumes.

The art historians Roger Fry and Clive Bell recognize Cézanne's innovations as entirely new developments, which profoundly affect the shape of modern art. Basic among these is Cézanne's emphasis on the two-dimensional surface of the canvas. Notice in the still life that Cézanne tilts the plate toward the picture plane; the table itself is so positioned that the viewer senses that the objects may spill forward at any moment. The jug is intentionally distorted, with its mouth tilted forward toward the viewer while the base remains flat.

Conventional notions of Renaissance perspective are abandoned. Objects are painted as though viewed from different angles, a feature that Erle Loran has exhaustively demonstrated in several of Cézanne's paintings. The manner in which Cézanne abandons traditional perspective, representation as seen from the point of view of a particular viewer, allows him to accomplish some of his cherished objectives. In throwing images toward the picture plane, Cézanne

Plate 17. Paul Cézanne, 1839–1906, *Still Life with Milk Jug and Fruit,* c. 1886–90, oil on canvas. (Getty Images, The Bridgeman Art Library)

gives them a new artistic immediacy. He discovers a compelling way to represent a scene from multiple viewpoints, thereby exposing different aspects of an image at the same time.

These artistic forces show their effect, almost immediately after Cézanne's death, in the Analytical Cubism of Pablo Picasso and Georges Braque, treated in chapter 9, as well as in the work of others for generations thereafter. Cézanne's pioneering contributions to art and his unique influence through much of the half-century after his death in 1906 become especially evident in his later work, beginning roughly the late 1880s.

While Cézanne's feet remain firmly on nature's ground, he discovers increasingly intriguing paths toward abstract representation. This is especially evi-

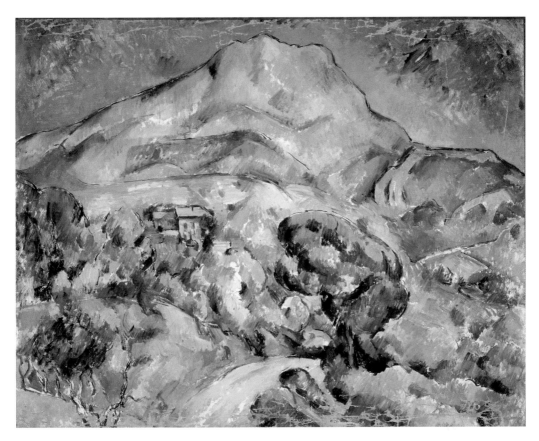

Plate 18. Paul Cézanne, 1839–1906, *Mont Sainte-Victoire, above the Tholonet Road,* 1900, oil on canvas. (Hermitage, St. Petersburg, Russia. Photo by Scala / Art Resource, NY)

dent in the evolution of his beloved Mont Sainte-Victoire paintings. Cézanne painted the mountain from different sites and from the same site at different stages in his artistic exploration of the mountain. Plate 18 shows a typical example from 1900, just beyond midway in the series of Mont Sainte-Victoire paintings. The melody is carried by large patches of freely applied brush and hue, all compatibly arranged so as to meld the mountain with the foreground. In later paintings in the Mont Sainte-Victoire series, Cézanne seems to be increasingly under the influence of an irresistible force, a frantic compulsion to share his intense emotional response to this subject with which he has lived for so long.

People have marveled at the difference between what their eyes and Cézanne's have grasped in viewing the mountain. They frequently report hav-

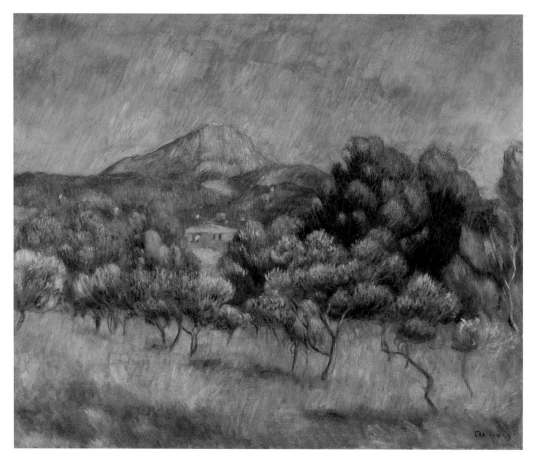

Plate 19. Pierre-Auguste Renoir, 1841–1919, *Mont Sainte-Victoire*, 1889, oil on canvas, 20⅞ × 25¼ in. (The Katherine Ordway Collection, 1980.12.14, Yale University Art Gallery / Art Resource, NY)

ing seen a rather unremarkable mountain, blue-gray or gray-blue, depending on the light, and also rather commonplace in size and shape. Along with thousands of other viewers, I was privileged to see the mountain the way Cézanne saw it, thanks to the nearly two dozen paintings of the site in the 2006 National Gallery of Art show and the 1996 Philadelphia Museum of Art show. The catalogues of both shows have excellent color plates.[3] The pictures are witness to his vision, not ours.

We cannot leave the subject of Mont Sainte-Victoire without showing its distinctly different treatment by Renoir, who sometimes painted with Cézanne. The distinct Renoir brush you saw earlier unifies this 1889 painting (plate

19). There is a serenity of handling and a far less nonrepresentational depiction than Cézanne's treatment of essentially the same scene by the late 1880s and the 1890s.

## MISREADING OF DISCOVERY ANTICIPATIONS FROM ART TO PHYSICS

We have mentioned the dark palette of early Cézanne paintings of the 1860s. In roughly the same period, Edouard Manet also frequently adopted stark tonal contrast, strong lights and darks, as, for example, in *The Dead Toreador* (1864), shown in figure 23. As you can see, here Manet makes minimal use of anchoring shadow, often referred to as *cast shadow*,[4] owing to the interruption of the light path by the body. This suggested to one author that, since the body appeared to him to float, the painting shows that Manet sensed something wrong with Newton's theory of gravity!

It is entirely appropriate that we give attention to such a thesis, impinging as it does on interpretations from art to physics. Is it reasonable to assume that Manet was revealing here such a dramatic insight regarding physics, another

Figure 23. Edouard Manet, 1832–83, *The Dead Toreador,* c. 1864, oil on canvas, 76 × 153 cm. (Widener Collection. Image © 2007, Board of Trustees, National Gallery of Art, Washington, D.C.)

example, perhaps, of the oft-cited "collective unconscious"? Or was Manet expressing a purely artistic purpose? Manet frequently uses small cast-shadow areas, especially when anchoring single figures. The clearly artistic intent of such a strategy is evident in many of Manet's single-figure paintings. In several of these there is little cast shadow and a continuum between foreground and background, with no clear delineation between horizontal and vertical planes. Rather, one finds a beautifully orchestrated, continuous variation of tonal value in the background, from the bottom to the top of the painting.

An example (plate 20) is Manet's *The Ragpicker* (c. 1865–69), which hangs at the Norton Simon Foundation in Pasadena, California. On visiting that art museum and directly viewing the large, roughly life-size, painting, you are convinced of Manet's purely artistic strategy. The curator's printed commentary on the label accompanying the painting supports such a position, which is that Manet was strongly influenced by Velázquez's paintings of isolated standing figures in which background was treated in a fashion similar to that we have just seen in *The Dead Toreador:*

> *Ragpicker* is the largest of a group of paintings inspired by the Spanish artist Diego Velasquez' *Philosopher* series: monumental single figures . . . set into undefined backgrounds . . . Manet was impressed with Velasquez' treatment of background, which he felt disappeared, and "were made up of air which surrounds the subject" . . . Manet used this vague "disappearing" background, in which the floor and the walls lose their identity, in many paintings of this period. Regarding the painting of single figure, he wrote . . . "how difficult it is to place a figure alone on a canvas, and to concentrate all the interest on this single and unique figure and still keep it living and real. To paint two figures which get their interest from the duality of the two personalities is child's play in comparison."[5]

At the same time, when the dictates of pictorial representation suggest otherwise, Manet uses strong cast shadow and with clearly indicated horizontal and vertical planes. This may be seen in some of his landscapes and still lifes. In Manet's *The Port of Bordeaux* (1871, not shown), a busy harbor scene, the paint is applied thickly, with full attention to the midrange of tonal value, and with elaborate attention to cast shadow for the purpose of "anchoring" the forms. Apparently, Manet's alleged discomfort with gravity was sporadic! It had disappeared six years after his apparent revelation about gravity.

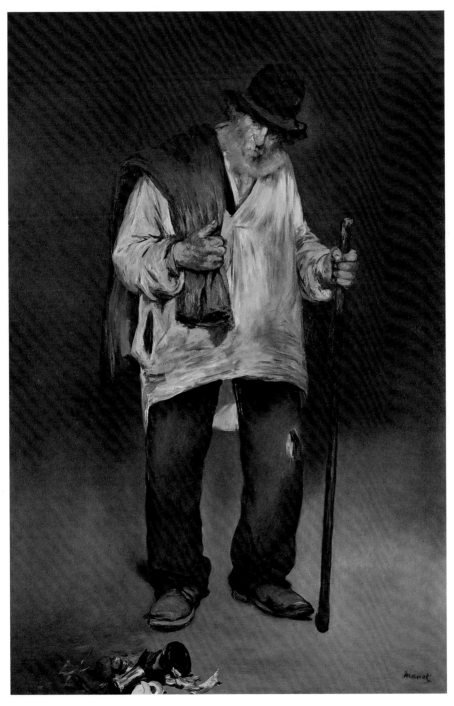

Plate 20. Edouard Manet, 1832–83, *The Ragpicker,* c. 1865–69. (The Norton Simon Foundation)

The same author casts the same net over Cézanne. The artist's strategy, which you saw earlier, of emphasizing the two-dimensional surface of the canvas and drawing the viewer into the picture plane by devices such as the tilting of tables in his still lifes, is taken as evidence that Cézanne, too, suspected something was wrong with the Newtonian conception of gravity!

Adopting that point of view, one may well wonder whether Van Gogh also had his finger on a secret of gravity when he chose to abandon cast shadow in his painting *The Bedroom at Arles* (1888, not shown). Consider his note on his preparatory sketch sent to his brother, Theo.[6] "[In this painting] color is to do everything . . . In a word, looking at the picture ought to rest the brain, or rather the imagination . . . You see how simple the conception is. The shadows and the cast shadows are suppressed; it is painted in free flat tints."

So we see what happens when overreaching attempts are made to establish "discovery interactions" from art to physics. The general theory of relativity of 1915, to be distinguished from the special theory of relativity of 1905, extended Newton's theory of gravity. It certainly had no effect on our understanding of everyday phenomena in France or elsewhere in 1864. Rather, its effects are most subtle and generally become important on a cosmic scale.

Even physicists and historians of science regard the general theory of relativity of 1915, which treated the question of gravity, as one of the most unanticipated ideas in the history of physics. The often invoked explanation for concurrences in terms of the *Zeitgeist* (loosely, the spirit of the time) is entirely inappropriate here. It was not even a smile on the face of physicists and certainly not "in the air" in the 1860s. From the perspective of physicists who have a deep commitment to art as well as to physics, such post hoc reasoning is truly painful.

If, for example, the general theory of relativity were not part of our present understanding, if Newton's gravity theory were still regarded as broadly viable, would such speculations over the meaning of Manet's and Cézanne's works be promulgated? Or, rather, would analysis be directed to the understanding of their purposes in terms of artistically driven imperatives felt by the painter?

One can understand the desire to connect particular milestones in art and physics when "modernist" developments for both occur in roughly parallel time periods. It is a commonplace to recognize that intellectual developments

in different disciplines may fertilize each other. But it does a disservice to make inappropriate connections.

The attempt to identify such connections between seemingly disparate disciplines is based on the reasonable premise that our intellectual endeavors do not take place truly isolated from each other and that discovery of relationships among them can enlighten us all. While excellent studies of influences between art and science have been made, the foregoing claims of discovery from art to physics are unconvincing.

The next chapter demonstrates how another claimed art-physics connection distorted the meaning of the physical picture of Einstein's special theory of relativity, as well as that of a very important art movement, Analytical Cubism, pioneered by Pablo Picasso and Georges Braque.

# 9  Cubism and the Expanding Horizon

It may well be argued that the foundations of Analytical Cubism were built by Paul Cézanne. So, before treating the remarkable innovations made by Georges Braque and Pablo Picasso, let us review the revolution in art initiated by Cézanne.

Cézanne's oeuvre can be separated into three or four periods, reflecting his discovery of ever-expanding frontiers of artistic expression. As you have seen, his palette and brush were dark and somber in the 1860s. For a time thereafter, they increasingly showed the influence of the impressionists. By roughly the late 1870s to early 1880s, Cézanne had abandoned the impressionists and sought in his work a recovery of well-defined forms. Finally, Cézanne's late period, which perhaps may be traced from the late 1880s to the end of his life in 1906, saw the full realization of his unique artistic powers and the most convincing evidence of the debt owed to him by future generations of artists.

## CÉZANNE AS GROUNDBREAKER

In that late period, Cézanne, while maintaining a clear determination to continue painting from nature, felt increasingly the need for release from many of its conventional constraints and a greater recognition of the power of pure form: "Painting after nature is not copying the objective, it's realizing our sensations . . . In painting there are two things: the eye and the brain. They should mutually aid one another, the eye through looking at nature, the brain through the logic of organized sensations, which provides the means of expression."[1]

Roger Fry noted that the late work belonged to a separate category, "the privileged departure point for modernism." During roughly the same period (in 1927), Clive Bell (1881–1964) made a similar observation regarding Cézanne's influence, causing painters to become increasingly occupied in their work with the nature of form and its aesthetic importance.[2]

The dictates of form, as conceived by Cézanne, guide the arrangement of brush strokes and the apposition of hues. Naturalism is in the service of abstraction. For the paintings of Cézanne's mature period, this observation by art historian Meyer Schapiro is especially insightful: "The visible world . . . is recreated through strokes of color among which are many we cannot identify with an object and yet are necessary for the harmony of the whole." The art historian John Adkins Richardson observes about Cézanne: "His transformation of [art] into a chromatic fugue as intricate and grandiose as the music of the Baroque is one of the most astonishing occurrences in the history of artistic innovation."[3] The observation goes to the heart of Cézanne's method of abstracting from nature.

It is interesting how well such a strategy fits metaphorically our attempts to extract a picture of physical reality. Our models of the physical world must necessarily be abstractions from a reality quite beyond our reach. Nevertheless, as you saw from examples cited in earlier chapters, even limited glimpses of that world paint a physical picture of great power and grandeur.

## THE FACETED WORLD OF ANALYTICAL CUBISM

Motivated by Cézanne's paintings shown in a large retrospective of his work in 1907, a year after his death, Picasso and Braque worked together for the next five years to extend his ideas. In that period, 1907 to 1912, they gave us one of the great innovations in twentieth century art. Labeled by most art historians as Analytical Cubism, it opened a new vista. In its continuation of the break from preimpressionist realism, Cubism represented new insight into the role of form in *seeing* art.

In *The Cubist Epoch,* Douglas Cooper points out that the inventions of Braque and Picasso were intended to allow the expression of volume with the aid of interlocking cubes—and, later, with more completely fragmented

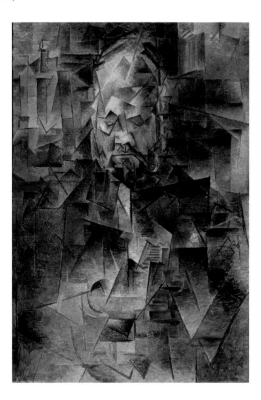

Plate 21.  Pablo Picasso, 1881–1973, *Portrait of Ambroise Vollard*, 1909–10, oil on canvas, 93 × 66 cm. (Pushkin Museum of Fine Arts, Moscow, Russia. Photo by Scala / Art Resource, NY. © 2007 Estate of Pablo Picasso / Artists Rights Society [ARS], New York)

forms.[4] Braque later explained that such fragmenting was meant to show all aspects of an object within the limitations imposed by the flat pictorial plane. This observation precisely echoes what you observed in some of Cézanne's late work as well.

The influence of Cézanne is evident in Georges Braque's *Houses at L'Estaque* (1908, not shown). The painting illustrates how the movement initiated by Braque and Picasso earned the label Cubism. The blocky buildings are stacked in their attempt to climb over each other onto the plane of the canvas. Further, they are tilted and turned relative to each other, as though to offer the viewer, simultaneously, a sense of their true, three-dimensional aspects within the limitations of the two-dimensional surface of the canvas.

As development proceeds, the cubist paintings of Braque and Picasso assume an increasingly intricate structure. This is suggested in Picasso's *Portrait of Ambroise Vollard* (1909–10) (plate 21). Both the subject and the background are broken into myriad faceted planes, turned in various directions.

All volumes fracture like broken shards of glass to show the viewer virtually every conceivable aspect of the original objects, but at one glance.

Typically for analytical cubist pictures, the range of hues is narrowly restricted but with remarkably rich variations of tone in the broken and reassembled faceted forms. The facets are arranged so as to maintain an artistic balance of weight, tone, and hue. The appeal of the painting is enhanced by the brush phrasing in each shard and by the way that phrasing allows the whole assembly of shards to sing in concert. The path of light guides our eyes toward Vollard's face, which reserves for itself the painting's central focus as the lightest light surrounded by relative darkness.

Earlier we discussed examples of the compositional role of the artistic element, line: Recall the *Three Graces* by Botticelli and Pollock's *Lavender Mist*. The Picasso portrait offers an excellent opportunity to again see the power of line in composition. At first glance the arrangement of lines in the painting may seem haphazard, but notice that diagonals balance against oppositely directed diagonals, while horizontals joust with vertical segments.

The art historian Hershel Chipp recognized the formalist upheaval introduced with the advent of Cubism. "The Cubist movement was a revolution in the visual arts so sweeping that the means by which images could be formalized in a painting changed more during the years from 1907 to 1914 than they had since the Renaissance . . . Cubism is, in fact, the immediate source of the formalist stream of abstract and nonfigurative painting that . . . dominated the art of the twentieth century."[5]

Favorable art criticism by Andre Salmon and Guillaume Appollinaire, who first labeled the movement "Cubism" in 1911, was particularly influential in bringing cubist art to public notice. Its influence was felt elsewhere than in painting, as in the work of sculptors such as Jacques Lipschitz, as well as in architecture and other fine arts. Even when Cubism had disappeared as a distinct movement, certainly by the 1920s, its effect in promoting formalism in art remained an influential force. But a misreading of an alleged connection of Cubism with Einstein's special theory of relativity (1905), promoted by some of the most ardent supporters of Cubism, contributed to a misunderstanding of Cubism's influence in physics.

## MISREADING RELATIVITY IN THE BIRTH OF CUBISM

The art historian Douglas Cooper has commented on the attempts to read into the birth of the Analytical Cubism of Braque and Picasso an incorrect interpretation based on Einstein's special theory of relativity. These misdirected efforts not only distort the meaning of relativity but also deflect from the aforementioned artistic purposes of Cubism. "Their analysis of forms, which involve combining different aspects of a single object, . . . has tempted some writers to read into it an implication of the 'fourth dimension,' the passage of time. Such an interpretation is certainly false . . . The various facets of forms are meant to exist and be seen *simultaneously* as elements disposed on a flat surface."[6]

As Braque and Picasso made clear, their intention was to compress the three spatial dimensions into the two-dimensional plane of the canvas, an objective, as we have seen, that was already present in Cézanne's still lifes. By representing different parts of particular objects simultaneously, using faceted planes of interlocking tone and color, Braque and Picasso hoped to give new insight into the three-dimensional object, *swallowed in one gulp,* so to speak.

Writing in 1912, the artists and writers Albert Gleizes and Jean Metzinger imagined the artist as "moving around an object to seize several successive appearances, which, fused in a single image, *reconstitute it in time.*" In later decades, some art historians reflecting on Cubism expressed the same mistaken view. As Meyer Schapiro, a distinguished twentieth-century art historian, pointed out in *The Unity of Picasso's Art,* this misinterpreted the expressed intentions of Braque and Picasso in their art, as well as that of Einstein himself in his special theory of relativity.[7]

Look at a painting in which the passage of time is suggested. While not regarded as truly an example of cubist art, *Nude Descending a Staircase, No. 2* (1912), by Marcel Duchamp (figure 24), does show some of the characteristics illustrated in this section. It again uses a narrow range of hues and relies on rhythm of tone. The dynamic characteristics of Duchamp's painting contrast sharply with the absence of time ordering in a typical analytical cubist painting. In fact, Duchamp had objected to what he referred to as the static character of Braque and Picasso's analytical cubist pictures, and he offered his *Nude Descending a Staircase* as a counterexample.

The motion of the semi-abstract figure from left to right down the stairs is explicitly indicated through the shifting of limbs and the successive light-

Figure 24. Marcel Duchamp, 1887–1968, *Nude Descending a Staircase, No. 2,* 1912, oil on canvas, 57⅞ × 35⅛ in. (Getty Images, Time and Life Pictures. Photo by Lee Boltin)

ening of tone as the figure clearly proceeds downward and across the canvas from left to right. The free motion of the figure contrasts with the inextricable fusion of adjoining parts in the cubist examples. Here, then, are shapes and rhythms of tonal value directing the path taken by the eye so as to suggest explicitly the time development of the figure's motion. In addition to the mistaken elapsed-time reference in early Cubism, some commentators on cubist painting, adapting the terminology of relativity, have frequently used the term the *fourth dimension* to refer even to the multiplicity of spatial orientations in the paintings, rather than the suggestion of a time dimension. Of course, that would be a usage without meaning in special relativity.

Let us hear Picasso himself on the subject: "Cubism [is an] art dealing primarily with forms [shapes] . . . Mathematics, trigonometry, chemistry, psychoanalysis, music—and what not—have been related to Cubism to give it an easier interpretation . . . Cubism has kept itself within the limits and limitations of painting, never pretending to go beyond it."[8]

The physicist and historian of science Gerald Holton and the Picasso scholar and art historian J. A. Richardson—as well as Einstein himself—stand convincingly behind Picasso's denial of such facile attempts to connect Analytical Cubism with the ideas of special relativity.[9] Recall also Braque's explanation of the artistic purposes underlying his cubist paintings.

If elapsed time is not represented in analytical cubist paintings, then consider the claim that those paintings show a multiplicity of spatial viewpoints simultaneously to the same observer. From what they themselves have said and from the direct evidence of the cubist pictures, this was indeed the objective of Braque and Picasso. But it is not the message of the special theory of relativity, which says that the observer does not unambiguously see spatially separated elements simultaneously. Indeed, that is a basic lesson of special relativity, as you may recall from the example of the rocket ships in chapter 7, treating the "failure of simultaneity at a distance." This may seem at first thought an unessential matter, a mere technicality, but it is of a piece with much conceptual misunderstanding that has spilled over into other intellectual disciplines, supposedly sanctioned by Einstein's relativity.

An art historian, Paul M. La Porte, sent Einstein a letter stating that in both relativity and art "allowance was made for the simultaneity *of several views*."[10] Such a position has been eagerly grasped in some intellectual quarters, suggesting that implicit in relativity is a message of cultural and social

relativism. Again, such a message is the opposite of relativity's lesson, as was pointed out in chapter 7.

Quoting Einstein in response to La Porte: "The essence of the Theory of Relativity has been incorrectly understood [in your paper] . . . The Theory says that the general laws are such that their form does not depend on the choice of the system of coordinates [i.e., to the choice of observers] . . . It is completely sufficient to describe the whole mathematically in relation to one system of coordinates."[11]

As you saw in chapter 7, relativity excludes a world of privileged observers, each privy to a different interpretation of physical law. Rather, Einstein's relativity postulate, the starting position and motivation for the entire theory, is that all observers see the same physics. Relativism is to be rejected; it is fundamentally mistaken to paraphrase relativity as "everything is relative." Relativity is more properly understood as a theory of invariance, as was pointed out in chapter 7.

The same author who dismissed Picasso's protestations regarding interpretations of Cubism declared also that Einstein knew nothing about modern art and could not properly comment on the controversy. But Einstein certainly knew about the content of his relativity theory and the pervasive misunderstanding of its content and message. Quite apart from the question of whether he had a proper appreciation of modern art was his recognition of the gross misinterpretation of special relativity, as exemplified by La Porte's contentions. La Porte's view persists in some quarters despite the absence of any historical evidence for connection between Analytical Cubism *during the time it was being created* and the special relativity theory of Einstein. This fact is exhaustively documented in the work of Linda Dalrymple Henderson.[12]

Special relativity was not "in the air" for artists in the period of Braque's and Picasso's Analytical Cubism, 1907 until 1912. It was only after the confirmation of a prediction of general relativity in 1919 that commentators created the connection between relativity and Cubism. In that year observational data from a total eclipse in South Africa showed that light grazing the sun was measurably bent, owing to the curvature of space near the sun. The report created a sensational response in the media.

Strangely enough, physicists did not themselves understand the concepts embodied in Einstein's special theory of relativity until about a decade after the 1905 advent of the theory. Holton (1996) points out that even the great

H. A. Lorentz and Henri Poincaré failed to understand the space-time generalizations that the theory incorporated. Their views were bound up with the notion that Einstein's special theory represented a correction confined to electrodynamics rather than a general recasting of our basic concepts of space and time.

University of Chicago professor Robert M. Wald notes that "Poincare not only failed to discover Special Relativity, he failed to embrace it after Einstein discovered it. Surely Einstein's deep conviction that the principle of relativity must be fundamentally embedded in the laws of physics—and his willingness to give up on the ether or anything else that did not accord with that view—was crucial to the discovery of Special Relativity."[13]

Einstein's special relativity theory is familiar and understood today by many physicists, so it is hard to appreciate the misunderstanding of the theory even years after its first publication in 1905 under the title *On the Electrodynamics of Moving Bodies.* Quoting Holton (1996), one of the foremost Einstein historical scholars: "Within physics, there was no immediate recognition of the transforming nature of Einstein's early papers . . . In France, the hierarchical and pyramidal structure of the profession was such that the opposition of Henri Poincare, the premier scientist of his time, to Einstein's Relativity made it very unadvisable for [any scientist] to publish in this field until after Poincare's death in 1912."[14]

# 10 The Growing Circle of Understanding

Artists and physicists strive to capture meaning in our inner and outer worlds. The difficulty of the attempt was long ago characterized by Plato, who likened the task to discerning reality from shadows cast on the walls of a cave. Nevertheless, abstraction from our direct experience has provided a foothold toward understanding something of those worlds. In the attempt to interpret those abstractions from reality, metaphor has frequently been a powerful guide in both art and physics.

In physics, visual images often provide symbolic clues to discovery. The insight leading Einstein to his monumental general theory of relativity, connecting gravity to the curvature of space-time, began with images such as that of a man seemingly released from the force of gravity so long as he was freely falling in an elevator. Somewhat earlier, his special theory of relativity was aided by recalling his speculations in youth about riding the crest of a light wave and, later, by the image of observers in passing rocket ships comparing their respective clock and meterstick readings.

Maxwell used his mechanical model of the ether, although incorrect, as a guide in his breakthrough electromagnetic theory, connecting electricity, magnetism, and light. An important contribution toward Maxwell's electromagnetic theory was Michael Faraday's discovery of electromagnetic induction. In that advance, Faraday was guided partly by invoking the idea of electric and magnetic fields, likening them to rubber bands traversing the space around electrical charges and magnetic poles. While the Faraday model of rubber bands did not survive, his field theory ideas did, and now its elaborations are fundamental to our understanding of all kinds of force fields.

I have not previously mentioned the role of the planetary model for the first significant picture of atomic structure using quantum ideas, proposed by the Danish physicist Niels Bohr. By invoking the example of the planets about the

sun, with significant modifications, Bohr conceived a reasonably successful picture imagining stable orbits of electrons about the nucleus of the atom. The model accounted well for some of the properties of the hydrogen atom, but, more significantly, it provided a first cut for later, more widely applicable, quantum mechanical ideas introduced by Erwin Schroedinger and other workers.

To take another example of the power of idealized models as guides to discovery, if we had not experienced wave phenomena in water, we might not have readily conceived of ways to test the wave properties of electrons and photons. On the other hand, our familiarity with projectiles such as stones and baseballs guided ways to test the particle properties of these very same entities, electrons and photons.

While objects in our familiar world behave either as waves or particles (i.e., ripples or stones), this is not the case in the Alice-in-Wonderland world of the quantum. As you saw earlier, experiments designed to determine whether the investigated object is a wave or a particle are thwarted by the fact that either property can be expressed by quantum-world entities, but not both simultaneously.

## THE THREAD OF CONNECTION

It is fascinating that, unlike the case of objects in our familiar world, in the quantum domain particles of a given kind are all identical. Unlike the unprovable claim that no two snowflakes are the same, the assertion that all quantum particles of a given kind are identical is demonstrable from the known physical consequences. The fact that one cannot tell the difference between two protons or two neutrons or two electrons when their positions are interchanged is a symmetry, one that has deep mathematical and physical implications. It helps explain, for example, why astronomical objects called neutron stars can form when sufficiently massive stars have exhausted their nuclear fusion energy.

These effects, involving particles such as electrons, neutrons, and protons, are a consequence of their belonging to the family of particles called fermions, which have the property that they must each occupy distinct states; no two protons, no two neutrons, and no two electrons may occupy the same state, as defined by their four quantum numbers, noted in chapter 3. Never-

theless, under the compressive force of the gravitational collapse of a star, the outer electrons of the atom are forced into the atom's nucleus. The electrons can combine with the protons of the nucleus, leaving nuclear matter consisting entirely of neutrons. This process takes place in collapsing stars destined to be so-called neutron stars, stars consisting of neutron matter. The neutron star's density becomes about that of an atomic nucleus, about $10^{14}$ times that of common matter on the surface of the earth.

The immense force involved is unimaginably greater than that resisting the compression of marbles occupying their smallest packing space in a container. The neutron star's density becomes about that of an atomic nucleus. If the initial star mass is great enough, the gravitational compression can become inexorable, and the star compresses to such a density that even light is unable to escape. The remaining object is thus referred to as a black hole.

Understanding in the physical world depends on a tapestry of interwoven pattern. The foregoing observations provide background for an interesting case in point. In 1054, Chinese astronomers recorded the sighting of a bright light in the sky, visible even in daylight. We now recognize that what they saw was a supernova, an explosion that releases vast amounts of energy when a sufficiently massive star nears the later stages of its life. Its nuclear fusion energy having been largely spent and now subject to the unbalanced pressure of gravitational collapse, the excess potential energy from that collapse is relieved by the release of vast energy, the supernova explosion. The process may continue, leading to the formation of the neutron star.

In 1967, about nine hundred years after the sighting of the bright star in China, Jocelyn Bell, a young astronomy graduate student at Cambridge working under the direction of Antony Hewish, came upon the evidence of a strange set of signals from their radio telescope. Unlike phenomena commonly expected from outer space, these radio signals were very regular, as if generated by the rotating beam of a lighthouse. The signals were about one-third of a second in duration and were spaced at regular intervals of about a second. Astronomers initially dubbed the source of the eerily regular, unknown signals as LGMs (for little green men). They soon found additional sources of such signals and came to recognize the new astronomical objects to be rapidly rotating neutron stars, called pulsars.

Astrophysicists then discovered that another source of a pulsar is in the core of the Crab Nebula (plate 22), the remains of the supernova explosion

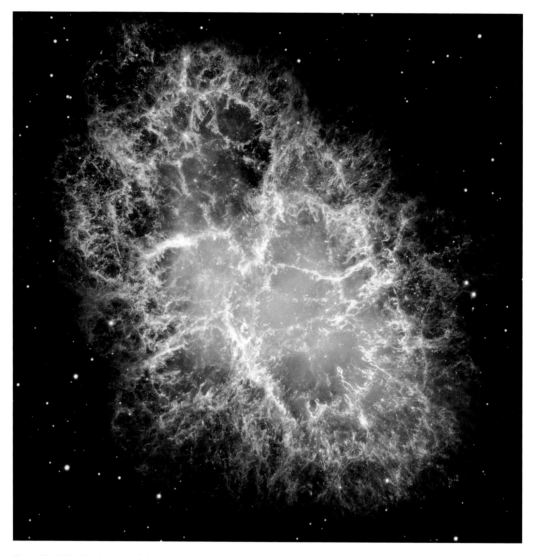

Plate 22. The Crab Nebula. (NASA, ESA, J. Hester and A. Loll [Arizona State University])

of the star observed in 1054. So it is that, in the interval between the observation of a star visible in daylight in 1054 and that by Jocelyn Bell of a pulsar in 1967, came the essential discoveries connecting such phenomena. As you have seen in broad outline, these observations derive from an arduous twentieth-century journey in the realm of quantum mechanics, atomic and nuclear physics, and astrophysics.

## VISUALIZING THE NONVERBALIZABLE

In their creative endeavors, the responses of artists to the wonders as well as the incitements of the modern world have assumed a variety of forms. These stimuli to the creative imagination are expressed in many ways. In this so-called postmodern period, the modes of expression in art are rather free-wheeling, including performance art, large installations in museums and parks, and video art.

In painting, all of the forms are in full bloom. Some examples of contemporary painting are selected here to suggest, but by no means begin fully to encompass, the diversity and vitality of the visual arts today. That would be an impossible task and, as stated at the outset, no survey of art or physics is intended in this work. The few selected examples retain the traditional concern for compositional integrity, including questions of symmetry, redress of broken symmetry, and recovery of unity.

Consider the acrylic painting shown in plate 23, *Solarium,* by the distinguished contemporary artist Michael Kessler. Kessler's work has been described as nature-based abstraction. The artist describes his motivation and process:

> [About four decades ago] I began by painting landscapes, but . . . it was the inner dynamics of the natural world that grasped my attention . . . I wanted to peel away the surface so that I could better understand the workings of nature. [But] I wanted to do this within the realm of art, not science . . . Appearances are deceptive and anyone who is interested in the true nature of the universe knows that there are far more questions than answers . . . I want my paintings to reflect both the desire to know and the futility of trying to know. The main thing I want my work to convey, however, is a sense of awe and wonder at the vast universe we can never comprehend.[1]

The artist Jean Constant, whose art background and training are in the fine arts, works in the digital medium as well as in oils and acrylics. He actively promotes interaction between artists and mathematicians, both internationally and in the United States. "My work is a poetic visualization of mathematical algorithms . . . As an artist, I use the tools of mathematics to create new perspectives . . . These days, science is bringing art back to where it belongs, a partner in the act of discovery of the world around us."[2]

Plate 23. Michael Kessler, *Solarium,* 72 × 48 in. (Reproduced with permission of the artist)

Plate 24. Jean Constant, *Newton Polynomial Transgression,* 2002, mixed media on canvas. (© 2007 Jean Constant, www.hermay.org)

Plate 24 shows his 2002 painting in mixed media on canvas, entitled *Newton Polynomial Transgression.* Notice that, while this is nominally computer art, Jean Constant's training in fine art is clearly evident. Compositional balance of forms and color make for a beautifully harmonious work.

Allan Leventhal works primarily in watercolor. His subjects may include a string quartet in concert, an Italian street scene or landscape, a rundown beach house near a shore in Costa Rica, or an abandoned shack in Cerrillos, New Mexico. To all of these, he brings a lyricism and mastery that reward the viewer far more than his humble painting subjects would seem to offer. The watercolor medium requires a special set of skills because of the required immediacy of wet techniques, which tolerate only limited reworking. Careful plan-

Plate 25. Allan Leventhal, *Fiano,* 2007, watercolor on paper. (Reproduced with permission of the artist)

ning is crucial before committing brush to paper. The painting *Fiano* (plate 25) shows, in Leventhal's words,

> a cluster of Tuscan farm buildings in the hazy mid-day heat of an Italian summer. Its colors are primarily orange, blue, and white, with the hues arranged so as to form their own interior shapes. Cerulean blue, a granulating color [containing some particles of pigment in suspension], was brushed into damp orange, and then partially lifted out to add interest to the shady side of the large building. The shapes are kept simple and connected into a unified whole. Hard edges are played off some soft edges and graphite lines are used to delineate shapes whose hues remain the same.[3]

Kinga Czerska is a young artist who brings a fresh eye to earlier forms in modern art. While some of her paintings would seem to revive the earlier stripe-painting tradition, her original approach reveals a delicacy and nuance that

Plate 26. Kinga Czerska, *Metamorphosis,* oil on canvas, 40 × 60 in. (Reproduced with permission of the artist)

give an ethereal quality to her work, as seen in plate 26. The lines seem to float, partially supported on almost weightless ovals and on a subtly laid-in sea of perfectly right-on pale green. The gossamer patterns are supported, as on a light skeleton, by widely interspersed stripes of a darker value that is still compatible with the subtly selected hues elsewhere.

John Winslow is a distinguished artist whose work is in the realistic tradition.[4] His generally large-format paintings, executed with remarkable craft, often become stage sets that are comments on life. In *Norwegian Nights* (plate 27), notice the wonderful selection of adjacent and overlapping, nearly transparent sheets of color, revealing an exquisite compatibility of related hues. See also the distribution and interrelation of hues, values, and shapes, all with a mind to compositional unity.

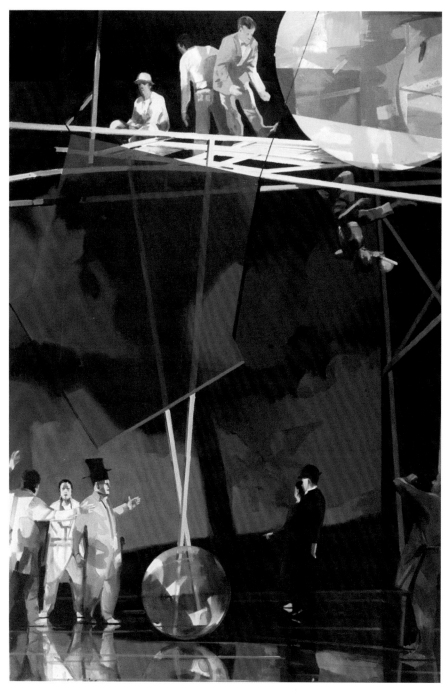

Plate 27. John Winslow, *Norwegian Nights,* oil on canvas, 60 × 40 in. (Reproduced with permission of the artist)

## SYMMETRY LOST AND RECOVERED

Modern physical discovery has often proceeded from hypothesizing particular symmetries. As you recall, Maxwell's crucial contribution of the displacement current was needed in order to satisfy an essential symmetry in electromagnetism: the conservation of electrical charge. It was subsequently further generalized, as quantum electrodynamics, to incorporate relativity and quantum mechanics. Recall that, as discussed in chapter 7, symmetry operates in Newton's mechanics as well. Since different inertial observers see the same physics, they are equivalent; there is no privileged observer, as was demonstrated earlier. This is expressed by physicists as Galilean invariance, the symmetry preserved when different inertial observers, traveling at ordinary speeds, compare notes.

As you saw, the notion of a privileged observer seemed to reappear in the realm of electromagnetism, threatening a loss of symmetry in physical law. But (again, chapter 7) symmetry was restored. Now it was Einstein's special relativity theory that removed the role of a special observer. Again, the invariance was preserved but now by a new and more comprehensive symmetry, expressed by the Lorentz transformation. Of course, the privileged-observer problem still persisted in accelerated reference frames, as it had for Newton, until Einstein's general relativity showed how symmetry could be restored even here.

You may have noticed a recurring theme in our brief sampling, tracing the broadening of our horizon, as viewed from successive vantage points, from Newton's laws of motion and gravitation, to electromagnetism, to special relativity, and to general relativity: often, successive discoveries restore threatened symmetries, which become recovered in a more comprehensive picture. Examples can be extended to modern particle physics, where, for example, the loss of mirror symmetry, treated in chapter 4, may well be reconciled when the problem is considered more broadly.[5]

## THE DEFEAT OF CLOSURE IN ART AND PHYSICS

We have found some of the properties characterizing great art: the striving for organic unity and a quality of inevitability, in many ways not unlike those in a coherent physical concept. And a great work of art has the flavor of inex-

haustibility. Why do we choose to become immersed repeatedly in the transcendent experience of a Brahms or Beethoven symphony or a great painting or sculpture? Quoting Dennis Donoghue, "We find things beautiful—in nature, in people, in art—when we sense we have not exhausted them, and our eyes, as Nietzche wrote specifically about artists, 'remain fixed on what remains veiled, even after the unveiling.'"[6]

By their nature, dictates of art ask us to stretch our imaginations and enter into a broader dialogue again and again. To participate fully in this aesthetic adventure, the observer must dedicate her mind's eye to the tapestry set before her by the artist. An observer must try to tap into the artist's intention. Whereas in the experience of music, one is automatically tethered in time, one is not similarly constrained in viewing a painting or sculpture. Viewers in a museum often move rapidly from painting to painting, looking at "snapshots" the musical equivalent of which can hardly be imagined. To instead *see* a work of art, we must try to grasp the artist's strategies for providing a guided tour through space and time, inviting us to filter and transform paths woven through the canvas.

Art viewers in a gallery profit immeasurably by allowing their eyes to see what the object of art has to say about itself. Rather than hurrying from one artwork to another, quickly grasping only something of the content, they must also insist on the reward that comes from sensing also something of the form imbedded in the work, wherever it falls in the spectrum from literal representation to total abstraction.

The defeat of closure may be said to be one of the telling characteristics of great art. We sense something of this in the continuing afterglow we experience on finishing a book of great literature, hearing the last notes of a magnificent symphony, or seeing a fine work of visual art. The work remains with us, continues to speak its aesthetic message, and compels us to revisit it. And somehow we recognize open-endedness, suggesting that the tale will continue to reveal itself to us.

Similarly, we sense open-endedness in the inexhaustible unfolding of the physical mystery. A robust physical theory is characterized not only by its internal integrity but also by its capacity to grow, a quality we have explored. The development of Maxwell's equations (in chapter 6) offers a case in point. The framed equations in figure 17, as the comments accompanying the figure point out, symbolize a coherent composition in a truly conventional sense, made

from separate brush strokes contributed by researchers over hundreds of years. But here, too, closure escapes us. As a case in point, while classical electromagnetism has *not* been nullified by newer developments, it has been brought within a far broader horizon encompassing the relativistic and quantum worlds.

This capacity for an increasingly comprehensive understanding of the physical world has often been likened to the structure of an onion, where growth is accomplished by the accumulation of successive layers of similar appearance. But such a point of view is misleading, as we have already seen even with the necessarily limited number of examples possible in this book. A better analogy might be drawn with the ever-advancing and increasingly comprehensive patterns of an unbounded picture puzzle.

Newton's laws of motion, for example, are not so much nullified by Einstein's theories of relativity as made more encompassing. While the worldview is changed in the process, the earlier ideas remain valid within their domain of applicability. Similar comments apply to Maxwell's electromagnetic theory. In extending its use to the quantum realm, it at the same time changes the larger shape of the picture puzzle.[7]

Some of today's physicists, among them the string theorists, are attempting to reconcile the general theory of relativity, which is eminently successful on a large scale, with quantum mechanics, the theory that reveals its effects in the atomic and subatomic domains. But any new theory addressing the current no-man's-land where relativity and the quantum world collide will be tested for its ability to make falsifiable predictions and, at the same time, conform to the picture already established in the interior of the picture puzzle. At each stage, the earlier determinations of pattern are enhanced and altered by successive revelations, but it is likely that final compositional unity will remain unsatisfied. That final closure eludes us is an inspiration, for it holds forth the promise of an ever-expanding picture, beyond our abilities to comprehend fully.

In a 1918 speech in honor of the 60th birthday of Max Planck, the father of the quantum concept, Albert Einstein spoke of the distinct motives of different scientists for pursuing their calling. Among these, he cited the pure motivation of those like Planck: "Man seeks to form, in whatever manner is suitable, a simplified and lucid image of the world, a world picture, . . . That is what painters do, and poets and philosophers and natural scientists, all in their own way."[8]

The Bible tells us that in the beginning all was void. After the postulated big bang giving rise to our universe, homogeneity and featurelessness slowly gave way to form and matter and ultimately to an arena for meaningful comprehension by observers. Now *we* are on the scene. Certainly our mind's eye has taught us basic survival skills, but for a more fulfilling life we can also call upon its capacity to help us take aesthetic delight in what we see around us. The human impulse to grasp coherent images of the world emerges in many ways, including our devotion to creative visual expression and to our exploration of the physical world's mysteries. In filtering, transforming, and coherently reshaping the stuff of our experience, we are often surprised and always rewarded by some new treasure the world reveals to us.

# NOTES

## Chapter 1. The Mind's Eye as Interpreter

1. J. B. S. Haldane, British geneticist and biologist. A similar statement has also been attributed to Arthur Stanley Eddington, the astrophysicist who, in 1919, was prominently involved in a solar eclipse experiment. This experiment tested the prediction by Einstein that light would be bent owing to space-time curvature by mass (see ch. 7).

2. Quotation displayed over an archway in the Georgia O'Keeffe Museum, Santa Fe, NM. In this connection, another artist's comment is also illuminating. Paraphrasing Picasso: art is the lie that tells a greater truth.

3. The interested reader is referred to the following representative readings: Morris Weitz, "The Form-Content Distinction," in *Art and Philosophy,* edited by W. E. Kennick (New York: St. Martin's Press, 1964), 339–350; Clive Bell, "The Aesthetic Hypothesis," ibid., 33–46 [from Clive Bell, *Art* (New York, 1938)]; Duane Preble and Sarah Preble, "Form and Content," in *Artforms,* 3d ed. (New York: Harper and Row, 1985), 40–119; Rudolph Arnheim, *Visual Thinking* (Berkeley and Los Angeles: University of California Press, 1969), esp. chs. 3 and 14; Bates Lowery, *The Visual Experience* (New York: Prentice-Hall and Harry N. Abrams, 1977); Laurie Schneider Adams, *The Methodologies of Art* (Boulder, CO: Westview Press, 1996), 16–24; Graham Collier, *Form, Space, and Vision: A Discourse on Drawing* (Englewood Cliffs, NJ: Prentice-Hall, 1972); Henry N. Rasmusen, *Art Structure* (New York: McGraw-Hill, 1950); Henry Rankin Poore, *Composition in Art* (New York: Dover Publications, 1967); Paul C. Vitz and Arnold B. Glimcher, *Modern Art and Modern Science* (New York: Praeger Publishers, 1984). Vitz and Glimcher primarily make the connection between form in modern art and the visual sciences, such as photography.

4. Karl Popper (1902–92), who promulgated the idea of falsifiability as the test of a scientific idea, was one of the twentieth century's most important philosophers of science. He argued that scientific ideas cannot be confirmed but can only be disconfirmed.

5. Mara Beller, "The Sokal Hoax: At Whom Are We Laughing," *Physics Today* (September 1998): 29–34. See also Mara Beller, *Quantum Dialogue* (Chicago: University of Chicago Press, 1991).

6. Francis Bacon, *The Essays of Francis Bacon,* edited by M. A. Scott (New York: Charles Scribners, 1908). See also Daniel J. Boorstin, *The Seekers* (New York: Vintage Books, 1999).

7. Gerald Holton, *Einstein, History, and Other Passions* (Reading, MA: Addison-Wesley, 1996), 102.

8. Henri Poincaré, *Science and Hypothesis* (New York: Dover Publications, 1952), 141 [italics added].

9. David Gelernter, *Machine Beauty* (New York: Basic Books, 1998), 1.

## Chapter 2. What Is Saved and Why

1. The initial momentum of a system, $\mathbf{p}_i$, equals its final momentum, $\mathbf{p}_f$. Boldface indicates that momentum is a vector quantity; direction as well as magnitude enter into its description. For a material particle, $\mathbf{p} = m\,\mathbf{v}$, where $\mathbf{v}$ is also a vector quantity; velocity refers to the speed (the magnitude of the velocity) as well as its direction. Of course, the rifle is not a strictly isolated system, tied as it is to the shooter, who is, in turn, tied to the earth. Immediately after firing, the approximation is very roughly satisfied because of the greater inertia of the shooter and the earth. (Again, momentum, unlike energy, is a vector quantity; thus, both direction and magnitude are required in order to determine it. The *forward* momentum of the bullet is balanced by the gun's recoil, its *backward* momentum.)

2. While the photon has no rest mass, it does have momentum. The mathematical expression (neglecting directional cues) for the momentum of the photon is $p = h/\lambda$. Here, $p$ is the momentum of the photon, $h$ is Planck's constant, and $\lambda$ is the wavelength of the photon. The energy is is $E = h\nu$, where $\nu$ is the photon frequency.

3. The mathematically inclined may want a fuller explanation. The general form would use $\mathbf{L}$ (angular momentum) = $\mathbf{r} \times \mathbf{p}$, where, in the cross product, $\mathbf{r}$ is the position vector from the origin of coordinates to the particle having momentum $\mathbf{p}$. For the ice skater turning on point, it is convenient to use the rigid body form for rotation about a fixed axis, $\mathbf{L} = I\omega$, where $I$ is the moment of inertia and $\omega$ is the angular velocity; $I = \Sigma\, m_i \times r_i^2$, where $r_i$ is the distance of a given particle of mass $m_i$ to the fixed axis of rotation. Conservation of angular momentum would then allow equating $\mathbf{L}_1$ with $\mathbf{L}_2$, the angular momenta of the skater in the two configurations, turning on point with an unchanged axis of rotation. This point of view allows one to describe the problem in the descriptive terms used in this book.

4. A few representative references on groups and symmetry are Herman Weyl, *Symmetry* (Princeton: Princeton University Press, 1980); Eugene Wigner, *Symmetries and Reflections* (Bloomington: Indiana University Press, 1967), chs. 1 and 2; and Joseph Rosen, *Symmetry in Science* (New York: Springer-Verlag, 1995). An engaging introductory treatment of symmetry is Ian Stewart and Martin Golubitsky, *Fearful Symmetry* (Oxford, England: Blackwell Publishers, 1992).

5. For further examination of symmetries, the interested reader may consult Richard P. Feynman, Robert B. Leighton, and Matthew Sands, *The Feynman Lectures in Physics* (Reading, MA: Addison-Wesley, 1964), vol. 1, ch. 52, and Rosen, *Symmetry in Science,* section 7-4. More general quantum mechanical proofs may be found in most books on quantum mechanics.

6. Excellent introductory discussions of the dark matter mystery are to be found in Martin Rees, *Before the Beginning* (Reading, MA: Helix Books/Addison-Wesley, 1997), ch. 6; Lawrence M. Krauss, *The Fifth Essence* (New York: Basic Books, 1989); and Nancy E. Abrams and Joel R. Primack, *The View from the Center of the Universe* (New York: Riverhead Books, Penguin Group, 2005), part 2.

7. Fritz Zwicky, *Helvetica Physics Acta* 6 (1933): 110; Sinclair Smith, *Astrophysics Journal Letters* 83 (1936): 23.

8. V. C. Rubin and W. K. Ford, *Astrophysics Journal* 159 (1970): 379.

9. For example, as the distance from a mass center, such as the sun, increases, a planet's speed $v$ in circular orbit at radius $r$ will decrease. From Newton's second law of motion, the gravitational force on a planet orbiting the sun is related to the planet's motion as

$$G\,m\,M \mathbin{/} r^2 = m\,v^2 \mathbin{/} r.$$

Here, $G$ is the universal gravitational constant, $m$ is the mass of the planet, and $M$ is the sun's mass. From this equation one sees that $v^2r$ is a constant, equal to $GM$, so that in this case $v$ decreases with increasing distance $r$.

10. From the orbital calculation in note 9, $G\,M = v^2\,r$, assuming a solar geometry. Against expectations, the disk apparently continued to enclose mass with increase of the testing range, even well beyond the visible radius; stellar velocities in Andromeda remained essentially the same with increase of distance $r$ from the center. Further studies indicate that the term *dark matter* is apt, since the hidden mass does not interact with known forces other than gravity.

11. For a review article detailing evidence of dark matter in Andromeda, see Vera Rubin, "Dark Matter in Spiral Galaxies," *Scientific American,* June 1983.

12. An accessible review of recent evidence for dark matter is Abrams and Primack, *The View from the Center of the Universe.*

## Chapter 3. What Is Broken and How

1. Albert Einstein, "Physik und Realität," *Journal of the Franklin Institute* 221 (1936): 315, as cited by Gerald Holton in *Leonardo* 14, no. 3 (1980): 234.

2. The distinguished mathematician George Birkhoff expressed the situation as follows: "A symmetric problem need have no *stable* symmetric solutions." Quoted by Joe Rosen, *Symmetry in Science* (New York: Springer-Verlag, 1995), 129–131.

3. A 1967 paper by Steven Weinberg posited that the so-called weak and electromagnetic forces are linked; the distinction between the two is attributed to the breaking of an internal symmetry. The 1979 Nobel Prize for physics was awarded to Weinberg, Sheldon Lee Glashow, and Abdus Salam for "contributions to the theory of the unified weak and electromagnetic interaction between elementary particles." In part 3 of *Warped Passages* (New York: Harper Perennial, 2006), Lisa Randall discusses some of these topics in a descriptive manner (p. 194). See also Leon M. Lederman and Christopher T. Hill, *Symmetry and the Beautiful Universe* (Amherst, NY: Prometheus Books, 2004).

4. For some of the arguments from particle physics, see Nancy E. Abrams and Joel R. Primack, *The View from the Center of the Universe* (New York: Riverhead Books, Penguin Group, 2005), ch. 5, n. 31.

5. An accessible reference is Steven Weinberg, *The First Three Minutes* (New York: Basic Books, 1979).

6. Useful general sources of information on the WMAP are http://physicsweb.org/articles/world/19/5/5 and http://map.gsfc.nasa.gov/m_mm.html. The following brief report summarizes these data from the WMAP: Bertram Schwarzschild, "New Cosmic Microwave Background Results," *Physics Today,* May 2006, 16–18. References showing our deepening understanding of cosmic expansion are Alan Guth, *The Inflationary Universe* (Reading, MA: Helix Books / Addison-Wesley, 1997); Martin Rees, *Before the Beginning* (Reading, MA: Addison-Wesley, 1997); and Timothy Ferris, *The Whole Shebang* (New York: Simon and Schuster, 1997).

7. See, e.g., T. D. Lee, *Symmetries, Asymmetries, and the World of Physics* (Seattle: University of Washington Press, 1988). Note the summary on p. 25.

8. The reference is to the novel, *Catch-22,* by Joseph Heller (New York: Bantam Doubleday Dell Publishing Group, 1955), about servicemen in World War II who felt trapped by self-contradictory military regulations. In the story, Captain Yossarian, who has applied to be excused from further military duty owing to insanity, is denied because his request is proof that he is not insane.

9. Those interested in further detail may want to see R. Feynman, "Probability and Uncertainty: The Quantum Mechanical View of Nature," in *The Character of Physical Law* (Cambridge: MIT Press, 1965), 127–138. A classic reference for some of the interference experiments is Richard P. Feynman, Robert B. Leighton, and Matthew Sands, *The Feynman Lectures in Physics* (Reading, MA: Addison-Wesley, 1963), vol. 1, ch. 37. For the more mathematically inclined, a somewhat more detailed discussion appears in chapters 1 and 2 of volume 3.

10. Claus Jonssen, *Zeitschrift der Physik* 161 (1961): 454; P. G. Merli, G. F. Missirelli, and G. Pozzi, *American Journal of Physics* 44 (1976): 306; A. Tonomura, *American Journal of Physics* 57 (1989): 117.

11. Since the three different coordinate axes of the cube are equivalent, the energy is proportional to $n^2$, where $n^2 = n_x^2 + n_y^2 + n_z^2$ and $x$, $y$, and $z$ indicate the axes of the cube. Here the values of $n_x$, $n_y$, and $n_z$ must be integers having value equal to or greater than 1. So the smallest $n^2$ value is 3; $n_x = n_y = n_z = 1$. There is no ambiguity about assignment of the quantum numbers in this lowest energy state, or "ground state"; the energy remains the same because the listed permutations all give the same value of $n^2$. But for the next higher state the quantum numbers are not uniquely assignable: $n_x$, $n_y$, and $n_z$ may be assigned values 1,1,2 or 1,2,1 or 2,1,1 without change of energy. However, if all sides are different, as in an orange-crate shape rather than a cubical one, then the energy becomes proportional to $(n_x/l_x)^2 + (n_y/l_y)^2 + (n_z/l_z)^2$, where the $l$ symbols reresent the lengths of the sides of the box. Now the aforementioned degeneracy is removed. The reduction of symmetry releases formerly unavailable information.

## Chapter 4. The Balance of Shapes

1. "I don't see any difference between beauty and formal perfection . . . It is surprising . . . how rarely theorists of aesthetics have reflected on the category of form . . . Form is the distinguishing characteristic of art. Form can't be evaded; it is the coherence of the work of art." Denis Donoghue, *Speaking of Beauty* (New Haven: Yale University Press, 2003), ch. 4.

2. Robert Goldwater and Marco Treves, *Artists on Art from the Fourteenth to the Twentieth Century* (New York: Parthenon Books, 1972), 346; John Canaday, *What Is Art?* (New York: Alfred A. Knopf, 1980), 12, 13.

3. Charles Ginnever, *Roshamon* (Palo Alto, CA: Charles Ginnever and the Iris and B. Gerald Cantor Center for Visual Arts, Stanford University, 2000). See article by Bruce Nixon, 13 ff.

4. Edgar A. Whitney, *Complete Guide to Watercolor Painting* (New York: Watson-Guptill Publications, 1974), ch. 6.

5. Gail Levin, *Edward Hopper: The Art and the Artist* (New York: W. W. Norton and Whitney Museum of American Art, 1980); C. Troyen, J. A. Barter, J. L. Comey, E. B. Davis, and E. E. Roberts, *Edward Hopper* (Boston: MFA Publications, 2007).

6. Michelangelo, whose contributions to painting, sculpture, and architecture were enormous, is fittingly memorialized by Vasari. Giorgio Vasari gave a moving description of the

monumental achievement of Michelangelo in *The Lives of the Artists.* See the translation by J. C. Bondanella and P. Bondanella (Oxford: Oxford University Press, 1998), 455–457.

### Chapter 5.  Some Visual Elements in Art

1. Some representative references for elements and principles of design are Edgar A. Whitney, *Complete Guide to Watercolor Painting* (New York: Watson-Guptill, 1974), chs. 6 and 7, quotation on p. 89; *Techniques of the World's Great Painters,* edited by W. Januszczak (Secaucus, NJ: Chartwell Books, 1981); H. L. Cooke, *Painting Techniques of the Masters* (New York: Watson-Guptill, 1972); Bates Lowery, *The Visual Experience* (New York: Prentice-Hall and Harry N. Abrams, 1977); John Sloan, *Gist of Art* (New York: Dover Publications, 1939); and Edmund Burke Feldman, *Varieties of Visual Experience,* 2d ed. (New York: Prentice-Hall and Harry N. Abrams, 1981).

2. Hershel B. Chipp, *Theories of Modern Art* (Berkeley and Los Angeles: University of California Press, 1968), 36, 37.

3. Karl Popper, *The Logic of Scientific Discovery* (New York: Basic Books, 1959).

4. The struggle to find universal criteria for identifying good art is a longstanding one, which requires courage and fortitude. Among the many stout hearts who have ventured on that field of battle is the distinguished art historian Bates Lowery. He insightfully commented on the subject in *The Visual Experience*, ch. 16. While the comments are rather brief and his examples from art do not extend beyond the early nineteenth century, many of his insights are applicable over the range of art to the present.

5. Ernst H. Gombrich, *The Story of Art* (Englewood Cliffs, NJ: Prentice-Hall, 1983), 14.

6. Allan Leventhal, e-mail to the author, 2007.

7. Mannerism was a sixteenth-century movement characterized by the use of unnatural color and exaggerated extension of the human form, as in the torso, arms, legs, and fingers. An important proponent of this form was El Greco (1541–1614).

8. John Canaday, *What Is Art?* (New York: Alfred A. Knopf, 1980), 28.

9. E. G. Landau, *Jackson Pollock* (New York: Harry N. Abrams, 1989), 192, 193.

### Chapter 6.  Searching for Light

1. A life of Michelangelo by Irving Stone is entitled *The Agony and the Ecstasy* (New York: Doubleday, 1961). The title of the biography is aptly chosen, for it describes a life of art beset by daunting adversity and great creativity.

2. A reason for assuming charge conservation is that no violation has ever been observed. Further, the imposition of such a requirement leads to the Maxwell equations, which are consistent with all observed effects in classical electromagnetism. Charge conservation can be asserted on more fundamental grounds by invoking an associated symmetry, invariance under rotation of "internal coordinates." For further reading, see Charles Goebel, "Symmetry Laws," in *McGraw-Hill Encyclopedia of Physics* (New York: McGraw-Hill, 1983), 1137, and Leon Lederman and Christopher Hill, *Symmetry* (Amherst, NY: Prometheus Books, 2004), ch. 11, 239–246.

3. Conservation of electrical charge has been obeyed in all known reactions, so its flow

must satisfy a continuity relation; charge can't come out of, or disappear into, thin air. (This is analogous to the requirement imposed on a water course, for which outflow of incompressible fluid across any cross-sectional area must be equal to the rate of inflow.) In the absence of the second term on the right-hand side, the charge continuity requirement is not satisfied. The term introduced by Maxwell, the displacement current, is precisely the form required to guarantee charge conservation. The new equation satisfies a continuity relation, which expresses the fact that charge is conserved. Those mathematically inclined may want to see the calculation. Consider Maxwell's fourth equation, $\nabla \times \mathbf{B} = \mu_0 \mathbf{J} + (1 / c^2) \partial \mathbf{E} / \partial t$, shown in the lower right corner of figure 17. Applying the divergence operation ($\nabla \bullet$) on both sides of the equation, the left-hand side then equals 0, since the operation ($\nabla \bullet \nabla \times$) gives 0. From this, you have $\nabla \bullet \mathbf{J} = (-1 / \mu_0 c^2) (\partial / \partial t) \nabla \bullet \mathbf{E}$. Using Maxwell's first equation, $\nabla \bullet \mathbf{E} = \rho/\varepsilon_0$, listed in the upper left corner of the same figure, and the relationship $c^2 = 1 / \mu_0 \varepsilon_0$, you get the continuity equation for the charge: $\nabla \bullet \mathbf{J} = -\partial \rho / \partial t$, where $\rho$ is the charge density and $\mathbf{J}$ is the electrical current per unit cross-sectional area.

4. The wave equations may be derived from the Maxwell equations in figure 17. In free space $\rho = 0$ and $\mathbf{J} = 0$, so that Maxwell's first equation is $\nabla \bullet \mathbf{E} = 0$ and the fourth is $\nabla \times \mathbf{B} = (1 / c^2) \partial \mathbf{E} / \partial t$. Applying the curl operation ($\nabla \times$) on both sides of Maxwell's third equation gives $\nabla \times \nabla \times \mathbf{E} = -(\partial / \partial t) \nabla \times \mathbf{B}$. The left-hand side of this equation is mathematically equal to $\nabla (\nabla \bullet \mathbf{E}) - \nabla \bullet \nabla \mathbf{E}$ and reduces in one-dimensional free space to $-\nabla^2 \mathbf{E}$. The right-hand side can be rewritten, using the fourth equation in one-dimensional free space, as $(-1 / c^2) \partial^2 \mathbf{E} / \partial t^2$. Putting the two parts together gives $\nabla^2 \mathbf{E} = (1 / c^2) \partial^2 \mathbf{E} / \partial t^2$, the first listed wave equation. Similarly, starting with Maxwell's fourth equation, operating with the curl on both sides of the equation, and then substituting for $\nabla \times \mathbf{E}$ (from Maxwell's third equation) gives the second wave equation in one-dimensional free space.

5. Before Maxwell's giant leap, experiments (by W. Weber and F. Kohlrausch in 1856 and by Faraday on light) had already suggested that light was a phenomenon involving electric and magnetic fields. Louis Brown in *Physics Today* (January 2001), 68, makes this point, citing as references J. C. Maxwell, *A Treatise on Electricity and Magnetism* (Oxford, England: Clarendon Press, 1892), article 771, and C. W. F. Everett, *James Clerk Maxwell, Physical and Natural Philosopher* (New York: Scribner's, 1975), 99.

### Chapter 7. Einstein's Relativity and the Escape from Relativism

1. Galileo Galilei, *Dialogue Concerning the Two Chief World Systems,* translated by S. Drake (Madison: University of Wisconsin Press, 1974). Strictly speaking, the earth is not an inertial system. It rotates on its axis and revolves about the sun. But the associated accelerations are small relative to the acceleration of gravity at the surface of the earth, so a small deviation—probably not noticeable to the sea captain—would cause the ball to land ever so slightly away from the base of the mast.

2. Quite apart from the fundamental objections already mentioned, the material medium supporting light waves would have to be a most unusual one indeed. Since starlight reaches us from great distances through space largely devoid of ordinary matter, the medium would have to be very tenuous. Also, since conventional waves tend to go faster in more rigidly bound matter—say, in steel as compared with air—the wave-carrying medium would have to be

remarkably rigid to support a wave traveling at the speed of light, 300,000 kilometers per second. By contrast, the speed of sound even in a typical solid is about 5 kilometers per second, 60,000 times smaller than light speed.

3. Excerpted from Arthur Beiser, ed., *The World of Physics* (New York: McGraw-Hill, 1960), as cited by Kenneth W. Ford, *Classical and Modern Physics* (Lexington, MA: Xerox Publishing, 1972), 3:980.

4. Modern quantum electrodynamics, which introduces the quantum theory in extending the scope of classical electrodynamics, may be regarded as having reintroduced an ether but one quite unlike that expressed by Maxwell postulating a material medium carrying electromagnetic waves. For those interested in pursuing the question, an introductory comment appears in Frank Wilczek, "The Persistence of Ether," *Physics Today* (January 1999): 11–13.

5. You have a clock in your own reference frame, say, in your rocket ship, and there is also one in the ship passing you in the same direction at speed $v$ relative to your own. The other clock will appear to you to be ticking more slowly than will your own clock. If $T_0$ is a time interval, say, a second, in your own clock, and $T$ is that interval you read in the other clock, then they are related as follows: $T = T_0 / (1 - v^2/c^2)^{1/2}$. So, since $v$ is less than $c$, $T$ is always greater than $T_0$. And for relativistic speeds (i.e., $v$ coming close to $c$), the difference between the two time intervals becomes very significant.

Now consider length contraction. Comparing metersticks aligned in the same direction on both ships, where $l_0$ is the length of the stick on your own ship, then $L = L_0 (1 - v^2/c^2)^{1/2}$. So $L$ is always shorter than $L_0$.

Finally, consider how velocities are added in relativity theory. In Galilean relativity, you have the familiar addition of velocities. A rocket travels away from your position with speed $v$. It then fires another rocket, traveling in the same direction at speed $u'$ relative to the first. Galilean relativity would dictate that you measure the speed of the second rocket to be $u = v + u'$. But in Einstein's special relativity $u = (v + u') / (1 + v u' / c^2)$. So no matter how close to $c$ are the velocities $v$ and $u'$, $u$ will always be less than $c$. To show this, take $v$ and $u'$ each to be $c(1 - e)$, where $e$ is a number much less than 1. So their speeds are close to but, of course, as required, less than $c$. Then $u = 2 c (1 - e) / [1 + (1 - e)^2]$. Using the binomial expansion $(1 - e)^2 = 1 - 2e + e^2 \ldots$, $u$ becomes, approximately,

$$u = c [ (1 - e) / (1 - e + (e^2/2))].$$

That is, $u$ is less than $c$.

6. The impact of a cosmic ray proton with a nucleus in the atmosphere releases a shower of gammas (high-energy electromagnetic radiation) and pions. The gammas produce electron-positron pairs, which mutually annihilate, leading to lower energy gammas. The process continues until the gamma energies are too small to allow for production of further electron-positron pairs. As for the pions, they decay into muons, which come to ground. Sources of additional information on cosmic rays for the general reader include James W. Cronin, Thomas K. Gaisser, and Simon P. Swordy, "Cosmic Rays at the Energy Frontier," *Magnificent Cosmos* 9, no. 1 (Spring 1998): 62, and Eugene N. Parker, "Shielding Space Travelers," *Scientific American* (March 2006): 40.

An interesting observation from Parker's article: "Above every square centimeter of [Earth's] surface is a kilogram of air. It takes a vertical column of about 70 grams—about 1/14 the dis-

tance through the atmosphere, achieved at an altitude of 20–25 kilometers (60,000 to 80,000 feet)—before the average incoming proton hits the nucleus of an atom in the air." Fortunately for us, there's lots of atmosphere left to absorb most of the cascade of surviving particles. The remaining radiation at sea level is about 0.03 rem, corresponding to a few medical x-rays (somewhat more at the altitude of Santa Fe, more than 7,000 feet above sea level).

7. Newton's Second Law of motion: $F = ma$, where $F$ is the force applied in order for mass $m$ to be accelerated by an amount $a$.

Newton's law of gravitation: $F = GmM / r^2$, where $m$ is the same mass we have been referring to in the first law of motion, $M$ is a second mass, and $r$ is their separation. This allows us to equate the right-hand sides of the two equations: $ma = GmM / r^2$. When you cancel both $m$ values, what is left is $a = GM / r^2$. This says, for example, that, for a body falling to Earth, the acceleration does not depend on the mass of the falling body, but just on the mass $M$ of the earth and the distance $r$ between the two.

8. See, e.g., Edwin F. Taylor and John Archibald Wheeler, *Spacetime Physics* (San Francisco: W. H. Freeman, 1963). A mathematically more advanced and comprehensive source is Charles W. Misner, Kip S. Thorne, and John Archibald Wheeler, *Gravitation* (San Francisco: W. H. Freeman, 1970).

9. S. Chandrasekhar, *Truth and Beauty* (Chicago: University of Chicago Press, 1990), 54.

### Chapter 8. Form in Impressionism and Postimpressionism

1. Erle Loran, *Cézanne's Composition* (Berkeley and Los Angeles: University of California Press, 1970); John Rewald, *Cézanne* (New York: Harry N. Abrams, 1986); Paul Machotka, *Cézanne: Landscape into Art* (New Haven: Yale University Press, 1996), 51 [italics added].

2. Rewald, *Cézanne*, 228.

3. *Cezanne,* catalogue of the retrospective exhibition of Cézanne paintings shown at the Philadelphia Museum of Art (Philadelphia: Philadelphia Museum of Art, 1996); *Cezanne in Provence,* catalogue of the exhibition on the centenary of the death of Paul Cézanne (1839–1906), 2006 (Washington, DC: National Gallery of Art; Aix en Provence: Musee Granet, Communate du Pays d'Aix; Paris: Reunion des Musees Nationaux).

4. "Cast shadow" is made by an object on another surface when that object interrupts the path of light. This is in contrast to "body shadow," referring to the relatively dark spaces on the body itself, owing to the body's blocking of light from the light source.

5. Quotation is used with permission of the Norton Simon Foundation.

6. Letter quoted in Hershel Chipp, *Theories of Modern Art* (Berkeley and Los Angeles: University of California Press, 1968), 41.

### Chapter 9. Cubism and the Expanding Horizon

1. *Cezanne,* catalogue of the retrospective exhibition of Cézanne paintings shown at the Philadelphia Museum of Art (Philadelphia: Philadelphia Museum of Art, 1996), 37.

2. Roger Fry, *Cezanne: A Study of His Development* (London, 1927); Clive Bell, *Since Cezanne* (London, 1922).

3. J. A. Richardson, *Modern Art and Scientific Thought* (Urbana: University of Illinois Press, 1971), 36; Fry, *Cezanne,* 58, 59.

4. Douglas Cooper, *The Cubist Epoch* (London: Phaidon Press, with the Los Angeles County Museum of Art and the Metropolitan Museum of Art, 1970).

5. Hershel B. Chipp, *Theories of Modern Art* (Berkeley and Los Angeles: University of California Press, 1968), 193.

6. Cooper, *The Cubist Epoch,* 44 [italics added].

7. Albert Gleizes and Jean Metzinger, in Gerald Holton, *Einstein, History, and Other Passions* (Reading, MA: Addison-Wesley Publishing, 1996), 130 [italics added]; Meyer Schapiro, "Einstein and Cubism: Science and Art," in *The Unity of Picasso's Art* (New York: George Braziller, 2000), 135, 51–64.

8. Robert Goldwater and Marco Treves, eds., *Artists on Art, from the Fourteenth to the Twentieth Century* (New York: Pantheon Books, 1972), 418, 419.

9. Holton, *Einstein, History, and Other Passions,* 129–145; Gerald Holton, *Science and Antiscience* (Cambridge: Harvard University Press, 1993).

10. Paul M. La Porte, "Cubism and Relativity, with a Letter of Albert Einstein," *Art Journal* 25, no. 3 (1966): 246 [italics added].

11. Holton, *Einstein, History, and Other Passions,* 130.

12. Linda Dalrymple Henderson, *The Fourth Dimension and Non-Euclidean Geometry in Modern Art* (Princeton: Princeton University Press, 1983). See also the criticism by Lynn Gamwell, *Exploring the Invisible* (Princeton: Princeton University Press, 2002), who cites claims such as that of historian of science Arthur I. Miller in his *Einstein, Picasso* (New York: Basic Books, 2001): "The treatment of time in *Les Damoiselles d' Avignon* is quite complex. Einstein's temporal simultaneity shares with Picasso's the notion that there is no single preferred view of events." Gamwell also notes the similar statements in a book by San Francisco surgeon Leonard Shlain.

13. Robert Wald, letter in *Physics Today,* September 2004, 57.

14. Holton, *Einstein, History, and Other Passions,* 116.

## Chapter 10. The Growing Circle of Understanding

1. Michael Kessler was awarded the Rome Prize by the American Academy in Rome in 1990 and the Pollock/Krasner Award in painting in 1992. His paintings are in the collections of more than 20 major museums, including the San Francisco Museum of Modern Art, the Philadelphia Museum of Art, and the Museum of Fine Arts, Boston. For the artist's statement, see Julie Karabenick, "An Interview with Artist Michael Kessler," *Geoform,* February 2007, www.geoform.net/features/features_kessler.html.

2. Jean Constant has had a large number of international exhibitions of his art. He was closely involved in the organization of an international exhibition, *Art & Mathematique,* held October 18–27, 2006. Constant has taken many of the solutions of Wasan mathematics and reinterpreted them in terms of evocative computer-translated images. During the Edo period (1603–1867), a distinctive style of mathematics called Wasan was developed in Japan. The quotation is from an interview with Constant: Nancy Zimmerman, "Creative Trinity," in *Santa Fe Trend,* Summer 2006, 82.

3. Dr. Allan Leventhal has had many one-person art shows. In his past life, he was a distinguished clinical psychologist and author on clinical psychology, professor emeritus of psychology at the American University, and cofounder of the Washington Psychological Center. The quotation is from an e-mail to the author.

4. John Winslow is a Washington, DC–based figurative painter. The recipient of awards from the Louis Comfort Tiffany Foundation and the District of Columbia Commission on the Arts, he has exhibited paintings at the American Academy of Arts and Letters, the San Francisco Museum of Modern Art, the Brooklyn Museum, the Philadelphia Museum of Art, the Carnegie Institute, and many others. A selection of the public institutions that own his work includes the Corcoran, the Metropolitan Opera at Lincoln Center, the Butler Institute of Art, the New Orleans Museum of Art, the Washington, DC, Convention Center, the Katzen Museum of the American University, and the John A. Wilson Building City Hall Art Collection of Washington, DC.

5. Symmetry is recovered in a broader invariance, called CPT invariance, where $C$, $P$, and $T$ refer to the simultaneous inversion of charge (all positive charge replaced by negative), reflection of parity, and time reversal.

6. Dennis Donoghue, *Speaking of Beauty* (New Haven: Yale University Press, 2003), 121, quoting Alexander Nehamas, "The Return of the Beautiful: Morality, Pleasure, and the Value of Uncertainty," *Journal of Aesthetics and Art Criticism* 58, no. 4 (Fall 2000). Nehamas is quoting Friedriche Nietzche, *The Birth of Tragedy,* translated by Ronald Speirs (Cambridge: Cambridge University Press, 1999), section 15.

7. See, e.g., Susan Haack, *Defending Science—within Reason: Between Scientism and Cynicism* (New York: Prometheus Books, 2007); James Franklin, "Thomas Kuhn's Irrationalism," *New Criterion* 18, no. 10 (June 2000); Thomas Kuhn, *The Structure of Scientific Revolutions,* 3d ed. (Chicago: University of Chicago Press, 1996).

8. A. Einstein, "Principles of Research," in *Ideas and Opinions* (New York: Crown Publishers, 1954), 224.

abstraction in Cézanne's art, 102–5
abstraction in physics and art, 4
accelerated reference frames, 75, 84, 85, 129
action at a distance, 65–66
amber, 65
Ambler, E. , 28
Ampere's law, 69
analogous colors, 51
Analytical Cubism: new departure, 6, 111–13; and
    question of relativity, 113–18
Andromeda galaxy (M31), 17
angular momentum: and conservation, 11; and ice
    skater's spin, 11; and spatial isotropy, 13, 134n3
antimatter: and asymmetry, 21–30, 35–36, 134n4;
    and broken symmetry, 51, 134n6
Appollinaire, Guillaume, 113
Aristotle, 85
*Arrangement in Gray and Black (Whistler's Mother)*
    (Whistler), 37
art and physics, similarities and differences between,
    5–7
artistic weight balance, 38–46
*Artist's Father, Reading "L'Evenement"* (Cézanne), 97
art mediums, 58
Aspen Center for Physics, vii
atom, 15, 66

Bacon, Francis, 7
balance, 42
balance of diagonals, 41, 43
balance of form, 43, 44
balance of forms (shapes), 38–42, 90
ballerina, 38, 39
beauty: and David Gelernter, 8; and Denis
    Donoghue, 142n6; and Henri Poincaré, 7, 8;
    and S. Chandrasekhar, 88
*Bedroom at Arles* (Van Gogh), 108
Bell, Clive, on Cézanne, 101, 111
Bell, Jocelyn, 121
beta decay, 15
big bang: 19, 25; and antimatter asymmetry, 134n5
bilateral symmetry (formal balance), 45–47
Biot, Jean Baptiste, 64
black body, 26
black hole, 17, 88, 121

blank canvas, and symmetry, 22, 48
*Blue Monochrome* (Klein), 48
Blue Period, 55
Blue Riders (Blaue Reiter, Blue Horsemen), 54
*Boating* (Manet): balance of diagonals, 43; impres-
    sionistic, 90
Bohr, Niels: planetary model, 119; wave-particle
    duality, 34
Botticelli, Sandro: line in *Three Graces*, 61; *Prima-
    vera* (detail), 60
Braque, Georges, 6, 111–16; *Houses at L' Estaque*, 112
broken symmetry: and antimatter, 25; in evolving
    universe, 19, 24–27; with first brush stroke, 22;
    and freeing of information, 24–29, 35–36; in
    internal symmetry, 24; in mirror (left-right)
    symmetry, 28, 29; in natural processes, 22–24;
    and placing of handle on vase, 22; in Sakharov,
    135n4; in spiked crown splash, 22
brush and texture, 94–101, 104
Bryn Mawr College, 14

Cambridge, 121
Canaday, John, 37, 58
Cassatt, Mary, 89
cast shadow and gravity, question of: in Manet's
    paintings, 105–7; in Van Gogh's paintings, 108
Catch-22, 29
Cézanne, Paul: abstracting from nature, viii, 96–97,
    99–103, 110; abstraction in art of, 102–5; brush
    of, 96–99; comment on gravity (alleged), 108;
    impasto, 96; "music of the Baroque," 111; outside
    viewer, 99, 101; pioneer of modernism, 110–11;
    retrospective show (2007), 111
Cézanne, works of: *Artist's Father, Reading "L'Evene-
    ment,"* 97; *Great Pine,* 99, 100; *Mont Sainte-
    Victoire, above the Tholonet Road,* 103; *Still Life
    with Milk Jug and Fruits,* 102
Champollion, Jean-Françoise, 67
Chandrasekhar, S., 88
*Child with Whip* (Renoir), 95
Chipp, Hershel, 113
chroma (saturation, brilliance, intensity), 49
Clark, Sir Kenneth, vii
closed systems, 29–30
closure, defeat of, in art and physics, 129–31

cobalt, 28

coherence/unity in art, viii, 89, 94, 99–101

color: "collective unconscious," 106; factors affecting appearance, 51–52; hue, intensity, value, 49–53; mixing colored light, additive, 51–52; mixing color pigments, subtractive 51; primaries, secondaries, complementaries, 50–51; warm/cold, 50

complements, 51–52

composition in art and physics, viii, 5, 6

Compton, Karl, 32

conservation laws: for angular momentum, 11; and beta decay, 14–15; and electrical charge, 64, 69; for energy, 9, 10; for momentum, 11; and the neutrino, 14–15, 20

Constant, Jean, 123; *Newton Polynomial Progression*, 125

constraints in physics, 7

content and form, vii, 4, 5

continuous transformations: and Noether's theorem, 14; and symmetries, 13–14

Cooper, Douglas, iii, 111, 114

cosmic rays, 82–84

Cowan, Clyde, 15

Crab Nebula, 121, 122

creativity in art and physics, 7, 8

*Cubi X* (Smith), 39

Cubism, Analytical, 6, 111–13; connection to relativity, 113–18

Czerska, Kinga, 126–27; *Metamorphosis*, 127

dark energy, 16

dark matter, 16–20

*Dead Toreador* (Manet), 105

DeBroglie, Louis, 33

defeat of closure: in art, 129, 130; in physics, 6, 22, 130–31

degeneracy, energy, 35–36

De' Medici, Giuliano, 46–47

design elements and principles: in art, 9, 22, 38, 43–47; in physics, 9–15, 64–65

differences between art and physics, 6, 7

discovery claims, from art to physics, 105–9

displacement current, 69, 70, 129

dissonance in color, 51–52

Divisionism (Pointillism), 90, 99

double-slit experiment: duality (particle/wave), 31–34; electrons, 34; photon interference, 33–34

Duchamp, Marcel, 114–16; *Nude Descending a Staircase*, 115

Duke of Nemours, 45–47

*Early Sunday Morning* (Hopper), 43, 44

eclipse of 1919, 87

Edgerton, Harold, 23

egg tempera, 58

Einstein, Albert, viii, 21; on comprehensibility of universe, 21; and general relativity, 84–88; on Paul M. LaPorte, 116–17; on photoelectric effect, 32; on Max Planck, 131; on rejection of relativism, 6, 65, 75–79, 116–17; and special relativity, 6, 8, 64, 75–76, 79–84; and visual imagery, 119

electric field, 67–69

electrical charge, 67

electrical current, 69–70

electromagnetic force, 26

electromagnetic waves, 3, 71–72

electromagnetism: and relativism, 75; Maxwell theory, 26, 64–65, 70–71; stepping stones to, 65–69

electron, 15, 66, 69, 70

electron in a box, 35–36

elements and principles of design, 5, 64, 94

El Greco, 56

energy: conservation law, 9, 10, 14; degeneracy and symmetry, 35–36; energy states, 35; and time symmetry, 14

English Channel, 21

entropy, 23–24

equivalence principle, 85

ether, 76–79

ether wind, 78–79

Expressionism, 54–55

falsifiability, 7, 35

Faraday, Michael, and electromagnetic induction, 64, 68, 70, 119

Fermi, Enrico, 15

fermions, 120

*Fiano* (Leventhal), 126

fields, 66–70

fish in boundless sea, 21–22

Fitzgerald, George F., 78

Ford, Kent, 19

form: in art, 4–6, 37; in Cézanne, 110–11; and content, vii, 4–6; in Cubism, 111–13; in Impressionism, 89–95; in physics, 4–6, 21–27; in Post-impressionism, 90, 99–104

formal balance (bilateral symmetry), 45–47

forms (shapes), 5, 38–42

four forces, and the early universe, 26–28

Fry, Roger, on Cézanne, 101, 111

galaxies, 7, 17–20

Galilean invariance, 129

Galilean relativity, 74, 82

Galilean transformation, 82

Galilei, Galileo, 74
Gelernter, David, 6
general theory of relativity, 84–88, 119
German expressionists, 54
Ginnever, Charles, 39, 54
Gleizes, Albert, 114
Gombrich, Ernst H., 53
Goodacre, Glenna, 47
gravitation: force, 21, 26, 30; the moon and an apple, 65–66
gravity: and allegations about Manet's art, 105–8; Newton and Einstein on, 21, 65, 84–88, 140n7; and question of cast shadows, 108; and question of two-dimensionality, 108
graying, 52
*Grazing Horses 4 (Red Horses)* (Marc), 54–55
*Great Pine* (Cézanne), 99, 100
greenhouse, 10
*Grove Group I* (Marden), 48
gyroscope and angular momentum, 11, 134n2

Haldane, J. B. S., 3
harmonious (analogous) colors, 50
Hayward, R. W., 28
heat energy, 9
Heisenberg, Werner, 30–31
Henderson, Linda Dalrymple, 117
Henry, Joseph, 64
Hewish, Antony, 121
hieroglyphs, vii, 112
Hilbert, David, 14
Hoffman, Hans, 97
Holton, Gerald, 7, 8, 18, 116–18
Hopper, Edward, 43–45, 91; *Early Sunday Morning*, 43, 44; *Nighthawks*, 45
Hopper, Jo, 45
Hoppes, D. D., 28
*Houses at L'Estaque* (Braque), 112
Hubble Space Telescope (HST), 17; Ultra Deep Field image, 17–19
Hudson, R. P., 28
hue, 49–53, 56
Huygens, Christian, 31

idealized models as guides, 119–20
identical particles: distinct quantum states of, 120; and symmetry, 120
Impressionism, 5, 89–95, 98, 99, 104
induction, 7
inertial reference frames, and observer symmetry, 74–75, 84
infrared waves, 3, 10
intensity (chroma, saturation, brilliance), 49

interdisciplinary course, vii
interference experiment, 31–34
interferometer, 78
impasto, 98

Jonssen, Claus, 34

Kepler, Johannes, 74
Kerr, Roy, 88
Kessler, Michael, 123
Klein, Yves, *Blue Monochrome*, 48
Kurasawa, Akira, 41

Landau, E. G., 62
Laporte, Paul M., and relativism, 116–17
*Lavender Mist* (Pollock), 62
Le Bail, Louis, 101
Lee, T. D., 28
length contraction, 82, 139n5
Leventhal, Allan, 53, 125; *Fiano*, 126
Leverrier, Urbain, 87
Levin, Gail, 45
LGMs (Little Green Men), 121
light as an electromagnetic wave, 70–72
light speed: observer-independent, 71, 80; ultimate but finite, 79–82
line: in *Lavender Mist* (Pollock), 62, 113; in *Portrait of Ambroise Vollard* (Picasso), 112; in *Three Graces* (Botticelli), 60, 113
Lipschitz, Jacques, 113
*Lives of the Artists* (Vasari), 58
lodestone, 65
Loran, Erle, 99, 101
Lorentz, Hendrik, 78, 118
Lorentz transformation, 79, 80

Machotka, Paul, 99
magnetic field, 68–72
magnets, 68–70
Manet, Edouard, 14, 20, 90; and alleged anticipation of general relativity, 105–7; and balance of diagonals, 43; and question of cast shadow, 105–9
Manet, Edouard, works of: *Boating*, 43; *Dead Toreador*, 105; *Port of Bordeaux*, 106; *Ragpicker*, 107
Mannerism, 56
Marc, Franz, 54; *Grazing Horses 4 (Red Horses)*, 54–55
Marden, Brice, *Grove Group I*, 48
*Marriage of Giovanni Arnolfini and Giovanna Cenami* (also known as *The Arnolfini Wedding*) (Van Eyck), 56–59
mass, inertial and gravitational, 85–86, 140n7
mass-energy, 9, 10

mathematics, viii
Matisse, Henri, 54
matter-antimatter imbalance, 24–25, 135n4
Maxwell, James Clerk, viii, 6, 64, 65; and the ether,
   76
Maxwell's equations: and "cocktail party relativism,"
   75; and Einstein, 6, 64, 75–76; framed as artistic
   composition, 71–73; and light, 71–72
mechanics, 4–11, 30, 65, 125–28, 135
Mercury's perihelion, 87
Merli, P. G., 34
*Metamorphosis* (Czerska), 127
Metzinger, Jean, 114
Michelangelo (Buonarroti), viii, 47, 58
Michelson, Albert, 78
Michelson-Morley experiment, 78–79
microwave, 71; background radiation of, 26
Milky Way galaxy, 16; and rotation period, 17
Minimalism, 48–49
mirror symmetry: in art (bilateral symmetry, formal
   balance), 45–47; in physics (right-left symmetry),
   27–29
mixing color: light (additive), 51; paint (subtractive),
   51. *See also* color
modeling of shape with color (Cézanne), 101–2
Modernism, 4, 108–11
momentum: and conservation, 10, 13, 134n1; and
   spatial symmetry, 13
Monet, Claude: color, 89–91; form, 45; Impression-
   ism, 91–92; *Regatta at Argenteuil*, 91
*Mont Sainte-Victoire* (Renoir), 104
*Mont Sainte-Victoire, above the Tholonet Road*
   (Cézanne), 103
Mont Sainte-Victoire to viewer's eye: Cézanne, 102–
   4; Renoir, 104
moon's continuous fall, 74
Morisot, Berthe, 89
Morley, Edward W., 78–79
muon clock, 83–84

nanometer, 71
National Gallery of Art, 63
"near the beginning" scenario, 24–27
neutrino: and beta decay, 15; and conservation laws,
   15, 20
neutron, 15, 120–21
neutron star, 121
Newton, Isaac: color spectrum and, 51; and gravity,
   80, 84–85, 87, 108–9, 143–49
Newton and Einstein, 21, 65, 84–85, 140n7; and
   question of gravity in art, 105–8
*Newton Polynomial Progression* (Constant), 125
*Night Café* (Van Gogh), 52

*Nighthawks* (Hopper), 45
Noether, Emmy, 14
Noether's theorem, 14
Normans, 21
*Norwegian Nights* (Winslow), 128
nuclear force, 24
nuclear fusion, 121–22
nucleus of atom, 15
*Nude Descending a Staircase* (Duchamp), 115
null measurement and the ether, 78

observer independence: challenged in electromag-
   netism, 65; in Newton's laws, 65; saved by
   Einstein, 65
Oersted, Hans Christian, 64
O'Keeffe, Georgia, 4
*Old Guitarist* (Picasso), 56
Omaha Beach, 21

parasol, in Renoir's *Woman Gathering Flowers*,
   92–94
Pauli, Wolfgang, 15
perihelion of Mercury, 87
phase changes in universe, 26
photoelectric effect, 32
photon, 32–33, 79
photon momentum, 11, 134n2
photosynthesis, 10
physics, 9
Picasso, Pablo, viii, 4; Blue Period, 56; Cubism,
   6, 55–61; *Old Guitarist*, 56; *Portrait of Ambroise
   Vollard*, 112
picture puzzle, unbounded, 131
Pissarro, Camille, 5, 89, 98–99; *Vegetable Garden
   with Trees in Blossom*, 98
Planck, Max, 31–32, 131
Planck's constant, 31–32
planetary model in Bohr's atom, 119
Plato, 119
Poincaré, Henri, 7, 8, 117–18
Pointellism (Divisionism), 90–99
poles, 68
Pollock, Jackson, 61–63; *Lavender Mist*, 62
Popper, Karl, 7, 35
*Port of Bordeaux* (Manet), 106
*Portrait of Ambroise Vollard* (Picasso), 112
post hoc reasoning in art and physics, 108–9
Postimpressionism, 5, 90, 96–99; in works of
   Cézanne, 5, 110
postmodern period, 123
primary colors, 50–51
*Primavera* (detail) (Botticelli), 60
privileged observer and relativism, 129

proton, 15, 66, 120
pulsar, 121–22
push-pull, 52

quantization: and electron in a box 8, 35; and
    Planck's constant, 31; and reduction of box
    symmetry, 8; and wave-particle duality, 31–34
quantum, 30–1, 34
quantum electrodynamics, 129
quantum mechanics, confirmations and applica-
    tions, 34
quantum number, 35–7, 120–21

radio telescope, 121
radio waves, 3, 121
*Ragpicker* (Manet), 107; and gravity of Newton,
    107, 108
rebalance of symmetry, 38–45, 91–92
*Red Horses (Grazing Horses 4)* (Marc), 54–55
reference frames: accelerated, 84–85, 129; inertial, 74
*Regatta at Argenteuil* (Monet), 91
Reines, Frederick, 15
relativism, 6, 65, 75–79, 117, 129; and Einstein's
    rejection, 6, 65, 75–77, 79
relativity: and alleged anticipation by Manet, 8,
    105–7; general theory of, 84–88, 119; and incor-
    rect interpretations in art, 105–9, 114–18; and
    "privileged observer," 75–76; special theory of,
    6, 23, 79–84, 115–18; and symmetry, 6, 75–79
Renaissance perspective, 101–2
Renoir, Pierre-Auguste, 5, 92–95, 104–5; *Child with
    Whip*, 95; *Mont Sainte-Victoire*, 104; *Woman
    Gathering Flowers,* 92–94
retina, 71
Rewald, John, 99, 101
rhythm of forms (shapes), 54–56
rhythm of tone and line, 58–63
Richardson, John Adkins, 111, 116
Riemann, Georg Friedrich Bernard, 84
*Roshamon,* 38, 40–42
Rubin, Vera, 19–20, 135n10
Ruskin, John, 38

Sakharov, Andrei, 134n6
Salmon, Andre, 113
saturation (intensity, chroma, brilliance), 49
Savart, Françoise, 64
Schapiro, Meyer, 111, 114
Schroedinger, Erwin, viii
secondary colors, 50–51
seesaw, 38–43
Seurat, Georges, 90, 99; *Sunday Afternoon on the
    Island of La Grande Jatte,* 90

shadow, cast, 105–8
simultaneity of events, 80–82
Smith, David, 8, 38, 39, 54; *Cubi X,* 39
Smith, Sinclair, 19
solar eclipse, 87
"Solarium" (Kessler), 123
space-time, 85–88
spatial isotropy (directional symmetry) and angular
    momentum conservation, 14
spatial symmetry and momentum conservation, 13
special theory of relativity, 79–83, 114–18
speed of light, 71; and independence of observer,
    79, 80
spin, electron, 28, 35
*Still Life with Milk Jug and Fruits* (Cézanne), 102
still lifes, 101
string theory, 131
strong force, 26
*Sunday Afternoon on the Island of La Grande Jatte*
    (Seurat), 90
supernova of 1054, 121–22
symmetry: bilateral (formal), 45–48; in blank
    canvas, 21–22, 46, 48; in conservation laws,
    9–15; in cubic solid, 27; and direction in space,
    14; lost and recovered, 129; mirror, 27; in physi-
    cal law, 6, 9–20, 64, 69; rotational, 13–14; in
    rotation of vase or sphere, 12–13; temporal (time
    shift), 14; translational (shift of position), 13
symmetry breaking: of blank canvas, 21–22, 46,
    48; examples of (splash, puckered bowl), 22–23;
    of mirror symmetry, 27–29; revealing information
    8, 29, 35–36

testing: in art, 6, 52–53; in physics, 7, 8, 24–29, 35–
    36
thought (Gedanken) experiments, 81, 85
thread of connection, 120–22
*Three Graces* (detail from *Primavera*) (Botticelli),
    60
time dilation, 81–82, 139n5
time symmetry and energy conservation, 14
tonal value, 49
Tonamura, A., 34
transformations: Galilean, 82; Lorentz, 79, 80; and
    symmetry, 9–15
Tulse Hill, 76
two-dimensionality: and Cézanne, 101; from multiple
    viewpoints, 102; as precursor to Cubism, 101–2

Ultra Deep Field image, 17–19
ultraviolet waves, 3, 71
Uncertainty Principle, 30–31
unity. *See* coherence/unity in art

value (tone, tonal value), 49
Van Eyck, Jan, 56–58; *Marriage of Giovanni Arnolfini and Giovanna Cenami* (also known as *The Arnolfini Wedding*), 56–59; and oil mediums, 58
Van Gogh, Theo, 52, 108
Van Gogh, Vincent, 4, 52, 96; and gravity, 108
Van Gogh, works of: *Bedroom at Arles*, 108; *Night Café*, 52; *Wheatfields with Cypresses*, 96
Vasari, Giorgio, 136n4; *Lives of the Artists*, 58
*Vegetable Garden with Trees in Blossom* (Pissarro), 98
Velasquez, Diego, and Manet, 106
velocity, compounding of, 139n5
*Vietnam Women's Memorial* (Goodacre), 47
viewpoints, multiple, in Cézanne's art, 101
visible wavelengths, 71
visual images as metaphor in art of Bohr, Einstein, Faraday, and Maxwell, 119, 120

Wald, Robert M., 118
Walters Art Museum, 99
watercolor, 53, 125–26
water tank thought experiment, 86
water waves, 76–77
wavelength, DeBroglie, 33

wave-particle duality, 31–33; size scale, 33
weak force, 26, 28
Weinberg, Steven, 34
*Wheatfields with Cypresses* (Van Gogh), 96
Whistler, James A. McNeill, 37–38; *Arrangement in Gray and Black (Whistler's Mother)*, 37
Whitney, Edgar, 42, 45, 49
Wild Beasts (Les Fauves), 54
Wilkinson Microwave Anisotropy Project (WMAP), 25
WIMPS (weakly interacting massive particles), 20
Winslow, John, 127–28; *Norwegian Nights*, 128
*Woman Gathering Flowers* (Renoir), 93
WMAP (Wilkinson Microwave Anisotropy Project), 25
WMAP image, 25
Wu, C. S., 28

x-rays, 3

Yang, C. N., 28
Young, Thomas, 31–32, 67

*Zeitgeist,* 108
Zwicky, Fritz, 19